A History
☙ *of the* ☙
WALLKILL
CENTRAL SCHOOLS

A History
℘ *of the* ℘
WALLKILL
CENTRAL SCHOOLS

A.J. Schenkman and
Elizabeth Werlau

Charleston London

THE
History
PRESS

Published by The History Press
Charleston, SC 29403
www.historypress.net

First published 2013

Manufactured in the United States

ISBN 978.1.62619.155.6

Library of Congress CIP data applied for.

*Dedicated to the students of the Wallkill Central School District,
past, present and future.*

Contents

CONTENTS

Foreword

Greetings,

It is with tremendous pride that I recognize our community on the seventy-fifth anniversary of the Wallkill Central School District. My father and I still talk about his experience attending school in a one-room schoolhouse off of Forest Road. We have moved from those schoolhouses that dotted the countryside into the five existing buildings that include the Leptondale Elementary School, the Clare F. Ostrander Elementary School, the Plattekill Elementary School, the John G. Borden Middle School and the Wallkill Senior High School.

As you read through this book, you will experience the history of our community. I commend Libbie Werlau and Adam Schenkman for taking the time to create this outstanding book that captures our legacy. Our administrators, teachers, students and staff have experienced innovations in education over the years and have witnessed the integration of technology in the classroom. We can now take our students around the world without leaving the classroom.

Our graduates have moved on to become successful members in our community, throughout the state and country and around the world. I am proud to say that my wife and I, my parents, members of our extended family and now my children all attended the schools in our district. We have a great deal to be thankful for, and I recognize the support for our students and our schools by the community at large.

Foreword

This is a time for us to celebrate and recognize our accomplishments over the years. A highlight for me was being superintendent of schools during the planning stages for this celebration. I wish the district many more years of continued success, and I know that the future is bright.

Happy Anniversary!

Sincerely,
William Hecht
Wallkill Central School District, Class of 1979

Acknowledgements

A project of this scope would not be possible without the help of many, many individuals and organizations who willingly shared their time, expertise and memories with us over the two years it took to complete *A History of the Wallkill Central Schools*. Special thanks to Whitney Tarella Landis, our editor at The History Press; *The Shawangunk Journal*; *New York History Journal*; Sue Coy Doyle; Kim Kosteczko; Jean Poirier; Judy Golden; Fred Fowler; Kelly Nelson; Joseph Zupan; Mary Malfa; Rosemary Denardo Zappala; Kathy Napoleone; Linda Napoleone Garcia; Shawna Newkirk Reynolds; Dollyann Newkirk-Briggs; Dave Bartholomew; Tammy Seeland; Cory Mitchell; Michelle Greco; and Glen Botto. Retired Wallkill Assistant Superintendent for Educational Services Jose Sanchez and Wallkill Board of Education Vice-President Dennis O'Mara were a great source of help from the earliest stages of this endeavor.

We are extremely grateful to the members of the Plattekill Historical Society and the Historical Society of Shawangunk and Gardiner for the many documents, images and anecdotes that they provided. Special recognition is necessary for historian Shirley Anson of the Plattekill Historical Society, who aided us greatly in the research, image scanning and interview process that was so crucial to this book. We would also like to thank Carolyn and Stuart Crowell, Freda Fenn and Harold and Mary Lou Van Aken of the Shawangunk and Gardiner Historical Society for answering our many questions, providing images and providing information on the early schoolhouses. This same group is in the process of

restoring the historic Andries DuBois House in Wallkill, with the intent of establishing a one-room schoolhouse museum that will house many of the remaining treasures from a long-ago era and provide a unique educational opportunity for the students of the Wallkill Central School District and the surrounding community. They are to be commended for this admirable project. A special thank-you to Elaine Terwilliger Weed, author of the outstanding *One-Room Schools of the Town of Shawangunk, 1800–1943* and a member of the Wallkill Class of 1942, who took the time to meet with us and share her memories of being a student in the one-room Bruynswick School and the Wallkill High School.

We would like to acknowledge historian Carol A. Johnson, who maintains the incredible Haviland-Heidgerd Historical Collection at the Elting Memorial Library in New Paltz, including files on Wallkill District history; Ashley Hurlburt of Historic Huguenot Street; the Southeastern NY Library Resources Council and their Hudson River Valley Heritage Historical Newspaper Collection; the staff at the Marlboro, Plattekill and Wallkill Public Libraries; Debra Rosenfeld, John G. Borden Library Media Specialist; and Michael Grafe, Wallkill Central School District Media Aide, for their roles in preserving and promoting items of historical interest. Much of the information we discovered on the district's first and second high schools came about with the aid of Wallkill District Clerk Sherry Palen, who helped us navigate significant early district records.

The administrative team at Wallkill was extremely supportive throughout this process. Thank you to building principals Mike Rydell, Maureen Dart, Monica Hasbrouck and Rich Kelley for sharing yearbooks, pictures, stories and anniversary information with us and to John G. Borden Middle School principal Maggie Anderson for helping us to research the unique history of that building. We would especially like to thank Superintendent Kevin Castle and Yvonne Herrington, Assistant Superintendent for Educational Services, for their assistance with this project. Finally, this history came about largely as a result of working with former Wallkill Central School District Superintendent William Hecht (Wallkill Class of 1979), who supported the project from its earliest stages. His encouragement and guidance throughout the entire process has been invaluable.

Authors' Note

This project began as an effort to share district history with students and community members but grew larger and larger as we realized that to honor the seventy-five years of history since the centralization of the Wallkill Central School District, we had to go back at least a century further to tell the stories of the one- and two-room schoolhouses that existed long before the centralized district. We have attempted to provide an overview of the district's foundations, starting with the rural one-room schoolhouses

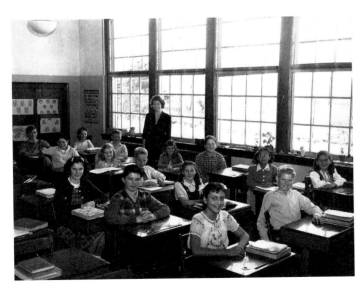

Students in
a Plattekill
Elementary
School classroom,
circa 1940s.
Authors' collection.

and leading up to the present configuration. There is no possible way in a written volume to individually recognize the thousands of people—faculty, staff, administrators, community members and students—who have been a part of Wallkill's rich history, but it is with certainty that we can state that each and every person who has walked these halls, studied within these classrooms and worked with students on a daily basis has left his or her undeniable mark on the history of the Wallkill Central School District.

Part I

Early Education
in the Wallkill and
Plattekill Valleys

Chapter 1

Early Education and
the Neighborhood Schools

The education of children in Ulster County's early history was most often done at home, through small private academies or at schools run by local churches. Private schools, in most cases, were only open to male students, although some wealthier families provided tutors for both male and female children. The private schools relied upon tuition, and most were run by prominent educated men in the community, such as the early Cole Academy in the Plattekill hamlet of Modena, which was headed by lawyer John Cole. Families of lesser means either schooled their children at home or sent them to schools with associations to churches such as the Quaker, Baptist and Dutch Reformed congregations in the towns of Shawangunk, Gardiner and Plattekill. In the church schools, the minister often served as the teacher, and courses included a mixture of academic subjects along with religious and moral instruction. In Ulster County, enrollment in church schools was usually open to both male and female students.

Histories of the towns of Shawangunk and Marlborough (from which the town of Plattekill was formed in 1800) indicate that schools existed in both towns by the late 1700s. It was not until the nineteenth century that district schools were formed as a result of the Common Schools Act of 1812. The districts usually consisted of a single school that was overseen by trustees who had been appointed by district residents. The New York State Education Department Board of Regents outlined the typical curriculum in the early schools, which consisted of instruction in reading, writing, arithmetic, geography and spelling. One of Plattekill's earliest district schools formed in Modena around this time,

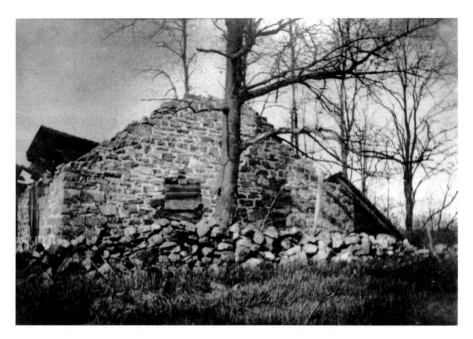

The first known public schoolhouse in the Plattekill hamlet of Modena was located north of the present-day intersection of Route 44/55 and Route 32. It was constructed of stone, unlike the later schoolhouses, which were simple wooden structures. The remains of the schoolhouse are shown here. The stone was later taken away for use in the foundations of local homes. *Courtesy of Town of Plattekill Historian's Office.*

and the hamlet of Wallkill had a district school by 1830. The first schoolhouse in this newly formed district "was a one-room wooden building on property located on the Wallkill River…a man named Mr. Rogers was the teacher. His students learned reading, writing, arithmetic and spelling."

The Common Schools Act called for partial state and municipal funding for local schools through a combination of state aid, town taxes and property taxes. Any shortages were covered through fees paid by parents of students attending the schools. Towns would lay out the boundaries of the school districts, and by the late 1800s, the towns of Shawangunk, Plattekill, Newburgh and Gardiner each had several school districts. While the Common Schools Act provided a wider range of educational opportunities for many students, those whose parents could not afford the tuition fees were sometimes prevented from attending school. It was not until 1867 that a free school law was enacted, providing funding through a statewide property tax system "to augment revenues from rate bills, the Common School Fund, and

local property taxes." At the same time that the Free Schools Act provided an education system for students in grades one through eight, secondary instruction remained relegated to the private academies (sometimes referred to as seminaries). Another form of private education was the "select school," a private school for younger students usually run from someone's home. Admission to the select schools was competitive, and students would apply for the coveted seats through a series of assessments. By the mid-1800s, there were at least two select schools in the region—one in the Plattekill hamlet of Clintondale, and another in the town of Shawangunk.

While select schools were an option for some students, in the towns of Gardiner, Plattekill and Shawangunk, education in the 1800s and early 1900s came primarily in the form of one-room schoolhouses, often referred to as neighborhood or common schools. The common schools were overseen by either a single elected trustee or a board of three trustees who would be elected to three-year terms. Annual district meetings were held for the trustees to report out to the community, while special meetings were called in instances when teachers needed to be hired or a vote needed to be taken on decisions such as building a new school or purchasing items for the existing school.

By law, the districts needed to maintain a library for the common schools. In some cases, the trustee would serve as a librarian, and in others, a librarian would be elected by residents. This position came with a small salary. The librarian would keep books at his home and visit the schools on a regular basis to deliver books to students. By the 1900s, the teacher was usually paid a small stipend in addition to his or her salary to maintain the district's library within the school. The other common job associated with the neighborhood schools was the janitor, usually a nearby resident, who would be responsible for cleaning the school, supplying fuel for the stove and the general maintenance of the school grounds.

During the 1800s, the school day typically began with scripture readings, the National Anthem, the Pledge of Allegiance and various songs, followed by health inspections where teachers checked students for cleanliness and general hygiene, including the monthly "lice inspections." Typical early one-room schoolhouses had separate entrances for boys and girls, separate outhouses for boys and girls, a small coatroom and a large main room with a wood- or coal-burning stove for heat. Some of the district schools had water sources on the property, while others relied on neighboring residents to provide water for the day. Neighbors also helped provide firewood and often provided room and board for teachers during the school year, while the teachers were expected to clean and maintain the interior of the school

Districts and parts.	Districts and parts of districts from which reports have been made.	Whole length of time any school has been kept therein.		Length of time such school has been kept by licensed teachers.		Amount of money received by districts the preceding year.		Number of children taught.	No. of do. over 5 and under 16 in said district.	Amount paid for teacher's wages besides public moneys.	Number of children between 5 and 16 taught in colored Schools.	Amount of public money received on account of children.
		Mos.	Days.	Mos.	Days.	For teacher's wages. Dolls. Cts.	For libraries. Dolls. Cts.					
Districts No. 5	5	11		11		61,74	15,68	94	91	206,	—	—
6	6	10		10		52,06	13,22	72	82	72,	—	
7	7	6		6		26,03	6,61	25	47	25.		
8	8	11	15	11	15	51,45	13,07	72	77	160,	—	
9	9	9		9		55,69	14,15	74	91	79.		
10	10	9		9		34,51	8,76	60	53	34,		
12	12	7	15	7	15	36,82	9,38	76	60	88.	—	
13	13	10	15	10	15	43,58	11,07	82	80	64¼		
14	14	7		7		24,22	6,15	32	43	27½	—	
17	17	6	15	6	15	42,97	10,92	75	66	30½		
18	18	8	15	8	15	50,84	12,91	56	94	39⅛		

An 1847 Town Superintendent of Common Schools report showing the eleven districts in the town of Shawangunk at the time. In addition to these eleven, whose borders were completely within the town, there were four joint districts in which the Town of Shawangunk shared responsibility for school districts with the surrounding towns of Plattekill, Newburgh and Montgomery. *Courtesy of Historic Huguenot Street Archives, Byron Terwilliger Papers, 1867–1962.*

and keep the woodstove burning. Teachers instructed students in grades one through eight in areas such as reading, writing, arithmetic, spelling, geography, history, languages and hygiene. Most common schools had a recitation bench, where the different grade levels were called at points during the day to recite their lessons for the teacher. Many of the schools had desks facing the walls or the center of the room, where students would work independently until their grade level was called to the front to work with the teacher.

A system of school commissioners was put into place by the 1850s. The commissioners were responsible for touring the county and writing

money.	Number of times visited by county superintendent.	Number of times visited by town superintendent.	Number of pupils who have attended less than 2 months.	Two months and less than 4.	Four months and less than 6.	Six months and less than 8.	Eight months and less than 10.	Ten months and less than 12.	Twelve months.	Number of unincorporated, select and private schools in said district.	Average number of pupils attending said schools.	Number of volumes in district library.
	2	2	24	27	16	13	14	—	—	0	0	204
	1	1	24	18	14	10	6	—	—	—	—	195
	0	1	2	3	4	16	—	—	—	—	—	100
	1	2	9	8	13	16	20	6	—	1	10	156
	2	2	25	24	11	6	8	—	—	—	—	170
	2	2	20	15	15	5	5	—	—	—	—	140
	2	2	43	20	9	4	—	—	—	—	—	150
	1	1	32	32	12	1	5	—	—	—	—	183
	3	2	15	8	5	4	—	—	—	—	—	98
	1	2	15	26	34	—	—	—	—	—	—	122
	0	2	25	13	13	5	—	—	—	—	—	210

lengthy reports detailing their observations of each school. They also had the authority to certify teachers and design teacher training programs. During their visits to the rural schools, they would quiz students on various subjects, inspect the school attendance and visitor registers to see that they were kept up to date and write up reports on the conditions found at each school. Their reports usually contained their recommendations for improving the school and opinions about the attendance and preparedness of the students in each school, as evidenced by this 1873 report published in the *New Paltz Independent*:

> In our visits to the schools since the last report was published, we have found several having vacation. This is not right. There is no better month in the year for school than October. Large children can attend, for the fall work is mostly out of the way and as the weather is pleasant small children need not stay at home. As our route however has been through Shawangunk,

which is a great country for hickory nuts, it is possible that the young hopefuls were at home gathering that important crop.

Other reports were not nearly as objective, describing various Ulster County schools as "very backward," with "children in heaps and piles, without a recitation bench" or possessing "miserable buildings in which no good farmer would keep his stock during the winter."

The school commissioners used their inspections to calculate the number of students enrolled in each district. This enrollment was compared with average daily attendance to determine the amount of public money to be apportioned by the commissioners. The tables below, published in the *New Paltz Independent* newspaper, show the varied distribution of public funds for one room schoolhouses in Shawangunk and Plattekill as of April 1874:

Plattekill Schoolhouses

1. Valley…$105.49
2. Caper Hill…$101.76
3. Ten Stone Meadow (Tucker's Corners)…$147.30
4. Modena…$165.47
5. Plattekill Hall (Ardonia)…$124.11
6. Orange County…$20.47
7. Thomas Thorn's (Clintondale)…$75.51
8. Gerow Neighborhood…$166.42
9. Lewisville…$121.44
10. Marlboro Mountains…$138.99

Shawangunk Schoolhouses

1. St. Elmo…$10.19
2. Plains Road…$120.77
3. New Hurley…$11.53
4. Walker Valley…$147.16
5. The Basin (Wallkill)…$275.44
6. Hogaburg…$129.62
7. Mount Valley…$170.80
8. Bruynswick…$134.53
9. Rutsonville…$8.17
10. New Prospect…$103.72

11. Pearl Street...$161.06
12. Ulsterville...$195.40
13. Galeville...$128.91

In addition to attendance, commissioners would report on the construction materials used for each schoolhouse, the general state of repair of each building, the number (or lack of) "privies" or outhouses available for students and the furnishings in each building. The results were published in the local newspapers to inform the public of how the money allotted to each district was being utilized.

District trustees would review the commissioner's reports before paying the teachers in charge of each schoolhouse. Typical teaching salaries for schools in Ulster County during the late 1800s and early 1900s were approximately $300 a year. Many teachers did not live in the area but would board with local families for a year or two. A Town of Plattekill advertisement in the *New Paltz Independent* published on November 18, 1869, painted a vivid picture of a teacher's responsibilities in exchange for such a salary:

> *Teacher Wanted: Any teacher, male or female, wishing to teach for small wages, board around, kindle fires, sweep out the school room and take up with a great deal of impertinence from the scholars and grumbling from the old folks, may hear of a situation, not a dozen miles from this village, applying at this office.*

With the passage of the Compulsory Education Law in 1893–94, the school commissioners became responsible not only for calculating attendance but for enforcing it as well. A history of education posted on the New York State Education Department's website explains that the New York State Regents "required children aged 8–12 to attend the full school year of 130 days; employed children aged 13–14 had to attend at least 80 days. The school year was increased to 160 days in 1896, 180 days in 1913, and has not changed since." As the local districts grew, financial support from New York State became even more closely tied to student attendance, and so the commissioners began sending out attendance officers to the various district schools on a regular basis, such as the following listed for the 1910–11 school year:

> *Plattekill: Harry Gee, Plattekill District 11*
> *Shawangunk: James Kain, Wallkill, Districts 2, 5, 6*
> *Shawangunk: J. Grant Upright, Wallkill, Districts 8, 10, 11, 13*
> *Shawangunk: G. H. Upright, Ulsterville, Districts 4, 7, 12*

The system of attendance officers gave way to the practice of hiring truant officers, who could take a student's parents to court if the student were not attending school regularly. By 1912, the school commissioner system evolved into a system of directors who were publicly elected and represented political parties. Ulster County was broken into four districts, with the area that would eventually become the Wallkill Central School District represented by the following directors: Daniel R. Gerow (R-Plattekill), R. Eugene Mattison (D-Gardiner) and Daniel Tuthill (D-Shawangunk). According to the New York State Board of Regents at the time, the new system determined the duty of a district superintendent to be "intelligent supervision" rather than "visitation of the rural schools."

Though the district schools were spread out, they were far from isolated. Most of the schools in Ulster County were no more than two miles apart from one another. Many of the neighborhood schools planned joint activities, and it was not uncommon for Ulster County teachers to spend only a year or two in one common school before moving to another within the township or county. The New Paltz State Normal School further helped create a sense of community among Ulster County Schools. Teachers in training began organizing countywide field days and "play picnics" by 1905. The field days were held on the grounds of the Normal School and included competitions in tennis, track and field, basketball throws, tug-of-war and bicycle races. To prepare for such activities, Normal School students would visit the rural schools and teach students folk dances, games and outdoor activities. The Normal School teachers were lauded in New York State Education Department publications for their progressive actions, such as opening the play picnic contests to any interested student rather than promoting competition between schools, introducing "lifetime fitness activities" that students could practice at home as well as in school and making a special effort to teach sports to the female students so that they could compete in the same activities offered to the boys.

By the early 1900s, the New York State Education Department offered Regents Exams in sixty-eight subjects. As part of a proud academic tradition that carries on a century later, the one-room and later John Borden and Wallkill High Schools would offer a wide variety of educational opportunities to students. By the 1920s, students in the John G. Borden School were preparing for Regents Exams in subjects ranging from Latin, German and French to mechanical drawing, plane geometry and the history of Great Britain and Ireland.

Meanwhile, at the common schools, teachers and trustees were increasingly required to collect more information about students' health, attendance and

academic preparation. The following is just a sample of questions taken from a 1933–34 Trustees Annual Statistical Report required of each common-school district by the New York State Department of Education:

Is hot food served at noon?

Is there a scale at the schoolhouse for weighing the children?

How frequently are children weighed?

Is morning health inspection made daily?

Is an adequate supply of drinking water available in the schoolhouse?

Has the school a bubbler fountain?

Was physical education regularly scheduled and conducted in the elementary grades totaling 120 minutes a week?

Number of arrests of habitual truants or incorrigibles (with formal procedure in court)?

Has the school a United States flag as required by article 27 of the Education Law of 1910?

Has instruction been given in the correct use and display of the flag?

Do the privies and water closets comply with the provisions of the "health and decency act?"

Has instruction been given in the human treatment of animals and birds as required by Article 26-b of the Education Law?

Has instruction in patriotism and citizenship been given to all pupils over 8 years of age as required by article 26-C of the Education Law?

Was Arbor Day observed in your district?

How many trees were planted on the school grounds during the past year?

In Ulster County, trustees were also required to purchase required items from a small budget, including a physical political globe, wall maps mounted on rollers that showed all of the continents, a permanent pupil record system (attendance book), a record book for trustee accounts and a legal tax receipt book. Trustees were also charged with inspecting the lighting in the schoolhouses under their responsibility, recording an accurate census of all children in their district from birth to age eighteen and inspecting outhouses and toilets for "proper sanitation and protection [so that] much necessary illness can be avoided."

The district lines of the common schools were often blurred, and in every town there were joint districts where students from two or more towns attended. Many of the one- and two-room schools described herein were considered joint schools at different points in their history. The common

schools did not have the authority to operate a high school, and so as local high schools—such as the Union Free High School in Wallkill, the Highland High School in Lloyd or the Walden High School in neighboring Orange County—opened in the early 1900s, some students continued their education at the school that was most conveniently located for them. By the mid-1930s, districts without their own high school were required to furnish transportation for any student who had completed the eighth grade and lived more than two miles from a high school. The remaining one-room schools held special meetings to determine which local high school was the most effective choice in terms of transportation costs. The John G. Borden High School in Wallkill saw enrollment more than double as result of this new legislation, as it allowed students in the farthest reaches of the towns of Plattekill, Shawangunk and parts of Newburgh, Gardiner and Montgomery to reach the high school. The school also saw an influx of students, as some of the neighborhood schools, such as the Plains Road School, began sending all of their students to Wallkill rather than allowing students to choose between the Borden School and the Walden High School.

Of the dozens of neighborhood schools that once dotted the towns of Newburgh, Plattekill, Shawangunk and Gardiner (and whose borders once encompassed parts of the towns of Marlboro and Montgomery), seventeen would later become part of the Wallkill Central School District. The history and location of many others that once existed in the region that would later become the Wallkill School District have sadly been lost to time. While centralization in 1938 brought about a unified school district, the majority of the one- and two-room schoolhouses in the area closed shortly after the formation of the Wallkill Central School District.

Chapter 2

Town of Plattekill

I attended the Ardonia schoolhouse in Ardonia, NY. It previously had an outhouse, and in 1952, indoor plumbing was brought indoors. The inside of the school had a pot-bellied stove, fueled by coal. There was a coal bin outside near the school [that] the older boys were designated to fill up the pail and feed the fire in winter. If you sat near the stove in winter, you were warm; if you were on the outer fringes, you were cold. The front of the classroom was a stage with slate chalkboards. At the end of the day, the teacher would choose one of the students to go outdoors and clap the erasers to get the chalk dust out of them. The floors were wood, and during Christmas break and summer vacation, the floors were oiled—I believe to keep the dust down.

Mornings in the warm weather would start out by raising the flag on the flagpole and saying the Pledge of Allegiance. If there was inclement weather, we'd say the pledge inside. The first teacher I had in 1952 was Betty Taylor—she was around twenty-one years old. She would go outside during recess and lunch break and play with all the kids. Some of the games were baseball, bike racing around the school and, in winter, sleigh riding.

During the nice weather, we'd eat our lunch outside, either in the field, or sit on the rocks around the school. Cold, rainy weather meant that we'd sit at our desks.

After Mrs. Taylor there, it was Mrs. Langwick and then Mrs. Graham. These teachers taught grades one through six and all subjects. They were not only teachers…they would also teach manners and cleanliness. Once or twice a year, a dental hygienist would come in and check the children's teeth and talk to the students regarding proper brushing.

I believe the Red Schoolhouse closed in 1956. All the students were sent to Plattekill Elementary. The students going into Junior High prior to 1956 in the Ardonia area were sent to Highland Central School. When the school closed, students going into seventh grade were sent to Wallkill Central School. After leaving Plattekill Elementary, the students would go to the Wallkill Junior and Senior High School, grades seven through twelve.—Kathy Napoleone, Wallkill High School Class of 1964

In the Modena School, I remember starting in the third grade, with the two rows of chairs and tables near the door to the room. The next set of two rows was set up for the fourth grade. And the last two rows closest to the floor to ceiling windows was the fifth grade—the Holy Grail! As I sat in third grade, my mind was already focused on those windows and spending time looking at the world pass us by. I remember the play yard was so large to us as we had to run around the field backstop. Who of us could forget the rainy days when we got to play in the basement auditorium on the scooter, playing kick ball? I cherish all the memories of Ms. Van Vliet and her tuna lunch—and always pulling my ears to a corner and making me stand there due to me being bad!—James Canty, Wallkill High School Class of 1978

In the town of Plattekill, mentions of early schools appear in histories of most of the town's hamlets, including New Hurley, Modena, Ardonia and Unionville. The neighborhood schools in the town closed one by one as consolidated districts were formed in Wallkill and the towns of Lloyd, Marlborough and New Paltz. The Modena School was the only Plattekill school to remain open long after consolidation, finally closing its doors for good in 1973.

The Plattekill Grange played an important role in the neighborhood schools. The Grange, the largest of its type in Ulster County, often hosted events and contests that encouraged the common schools to work together on community projects. The annual Grange Fair would feature exhibits from each of the neighborhood schools. For winning projects, students were awarded prizes such as sets of books and even gold coins. Schools were also awarded in gold coins for encouraging pupils to create projects focusing on areas such as gardening, healthy habits and dramatic and oratorical projects.

The Ardonia School, District No. 5, located on Farmer's Turnpike (present-day Milton Turnpike) in the town of Plattekill, was also informally known as "the little red schoolhouse" or "the school near Plattekill Hall" for its location near the old Plattekill Town Hall (today's Ardonia Market). The

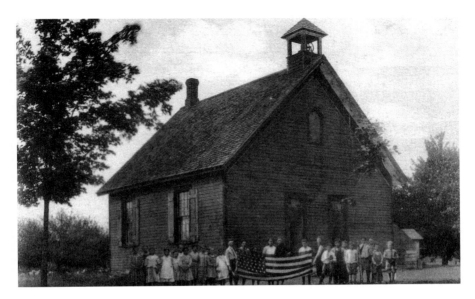

A 1908 postcard showing students outside of the Ardonia School. Today, the building is used as the Town of Plattekill Police Station. *Authors' collection.*

original Ardonia School was constructed around 1832 at the intersection of present-day Coy Road and Milton Turnpike on land donated by Benjamin Furmann for the purpose of establishing a school. On March 5, 1872, the building caught fire during the school day. The following report of the incident appeared in the *New Paltz Independent* the next week: "On Tuesday afternoon last week, the schoolhouse in District No. 5, in Plattekill, James Lowrey teacher, was discovered on fire. The children had just time to remove their books and etc. when the roof fell in. It is thought to have taken fire from the stove-pipe passing up through the roof."

A second structure was quickly erected, and by January 1873, an inspector noted the changes:

> *The schoolhouse at this place was burned down not long since, and a new edifice has been erected. The new building is more handsome and better furnished than the majority of schoolhouses are. Most of the scholars are very small, but their teacher seems to have bestowed much labor on them, and they displayed knowledge on some subjects which are frequently neglected by teachers.*

A later inspection report described the school as being a one-room building where "quiet and good order prevailed."

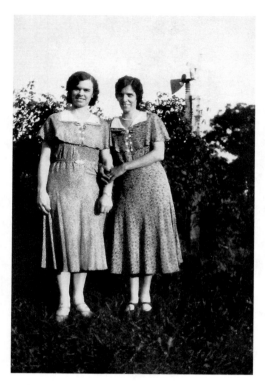

Undated photograph of the Cook sisters. On left is Margaret Cook Fosler, who taught at the Modena School and later became principal of the Plattekill Elementary School. Her sister Ruth Cook Coy (right) was a teacher at the one-room Ardonia School. *Courtesy of the Coy and Doyle families.*

At times, the attendance lists for the little building showed as many as forty-nine students enrolled under the tutelage of a single teacher. One teacher who brought national attention to the Ardonia School was Flora Malcolm, herself a former Ardonia student. A graduate of the New Paltz State Normal School, Malcolm returned to Ardonia in the early 1900s, where she was dismayed to see her former schoolhouse in a rundown state. Within a few short years, Malcolm transformed the building into a model for neighboring districts. According to articles she later would write for national publications, Malcolm brought in two wagonloads of furniture and encouraged the community to raise funds for an organ, new floors, microscopes for the students and even a school bell. Within a year of arriving at the Ardonia School, Malcolm began teaching courses in gardening and biology. Her students planted gardens and trees and built birdhouses that they placed around the school. Local residents helped the school by purchasing an adjoining lot on which they worked with students to construct a playground.

A report by the New York State Education Department in 1913 noted that Malcolm had increased the school's library from ten volumes to more than five hundred and praised her efforts in bringing a variety of courses to Ardonia, including folk dancing and first aid. She was also recognized for getting the community involved in projects to better the school. Her students gained recognition by having articles they wrote published in national journals such as *Garden Magazine* and the National Audubon Society's *Bird*

Lore. Malcolm remained at Ardonia until 1920, when she married John Nabor and began teaching at the Gerow School that adjoined his property. She also taught at the New Hurley School at some point in her career.

The Ardonia School remained open until 1956, when Common School District No. 5 of the Town of Plattekill was dissolved and the property and schoolhouses annexed to the Wallkill Central School District No. 1. The original school bell purchased during Malcolm's era is housed today at the Space Farms Zoo and Museum in Sussex County, New Jersey. The building was used as the Plattekill Town Hall from 1958 to 1973. Today, the Ardonia School building is home to the Town of Plattekill Police Department.

The **Gerow Neighborhood School District No. 8** was located on what is today Plattekill Ardonia Road in the town of Plattekill. The school, named for the Gerow family, who owned much of the land in that area, boasted a larger attendance than many other local neighborhood schools. At one point in 1876, teacher Ella Gerow was in charge of fifty-nine pupils. Despite the large population, the school commissioner who examined her school found students "ready with answers, and generally correct."

In the late 1800s, another school commissioner described the Gerow School as having "the reputation of being one of the best schools in the county" where "an examination of some of the less advanced classes proved that they had not been neglected for the sake of pushing the best pupils forward more rapidly, as is sometimes the case in schools." Another report noted:

> *This for many years has been considered one of the best schools in the county, and under its present management is in no danger of losing its ancient reputation. It is a positive pleasure to visit such a school. If the parents in other districts took the same interest in their schools, we are inclined to think in a few years they might have just cause to be proud of their children's proficiency as the people of the Valley are.*

One well-known teacher at the Gerow School was Ralph LeFevre, who later became editor of the *New Paltz Independent* newspaper. LeFevre's paper often focused on educational issues in Ulster and surrounding counties and published the commissioners' reports on each district. The Gerow School was a small one-room building, but the students there managed to turn one corner of the room into an extensive classroom library. Students took responsibility for the library and furnished it by making chairs out of orange crates and sewing curtains to cover the bookshelves. The school had a series

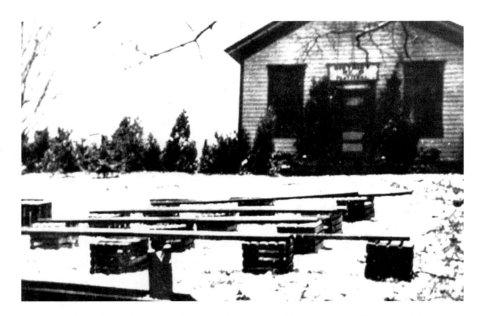

An undated image of the Gerow Neighborhood School in the town of Plattekill. Weather permitting, classes would be held outside, judging by the benches set up outside of the school. *Courtesy of Shirley Anson.*

of larger desks in the back of the room, with smaller desks at the front, close to the teacher's desk. There was a large woodstove in the middle of the room. A school inspector visiting the schoolhouse in 1870 wrote, "The enterprising inhabitants of District No. 8 Plattekill have been making extensive improvements in their schoolhouse grounds. The schoolhouse is a neat-looking edifice situated on a hill that commands a fine view of the surrounding county."

For most of its history, the Gerow School served students in grades one through eight. In 1925, the school began holding yearly reunions for former students and teachers at the start of each school year. By the early 1940s, however, attendance was dwindling, and students began preparing to attend the new Plattekill Elementary School. At the 1941 cornerstone ceremony for the new school at Plattekill, sixth-grade Gerow student Nancy Ruggiero represented the school and brought "an old time relic of the Gerow School" to place in the cornerstone.

The Gerow School closed in 1942 as a result of centralization, as elementary-age students began attending the Plattekill Elementary School, while older students were bussed to the John G. Borden High School. Today, the Gerow School building is a private residence.

Unidentified students and teacher outside of the Plattekill Valley School, circa 1900. *Courtesy of Shirley Anson.*

The Plattekill Valley School District No. 1, located near the present-day intersection of Plattekill Ardonia Road and Route 32 in the town of Plattekill, was first organized in the Baptist church that once stood near the Plattekill Community Cemetery. Nathaniel Sylvester wrote in his 1880 *History of Ulster County* that early teachers in this school included David M. Wygant, Aaron Raymond and John B. Morrison. In 1868, a proper one-room schoolhouse was constructed near the church. Students were allowed to spend their recess time outside in the old cemetery that adjoined the school property.

In its early years, the Valley School was often a target for inspectors, who noted the poor conditions of its desks and chairs—and even the appearance of the students: "Only 13 students were in attendance. All of them were quite backward, and from appearance, we should judge that the people in the neighborhood took very little interest in their school." The school closed in 1942, and Plattekill Valley students began attending the new Plattekill Elementary School. For many years, the former Valley school building was a private residence. The structure was eventually torn down in the 1990s.

The Prospect Hill School District No. 6 was located off of Quaker Street, near the town of Newburgh border in southern Plattekill on modern-day Prospect Hill Road. The first school in this area, known as the Birdsall School, served the community until the early 1880s, when it was closed after a school commissioner's report claimed it was "old, small, uncomfortable and in every way unfit for school purposes." (The original building was a single fourteen-by-eighteen-foot room.) A new school building was constructed on the same spot in either 1874 or 1883 at a cost of $808. Thomas Birdsall donated a half acre of land for the new building, which was soon described as "a model school" by the commissioner. The new schoolhouse was painted white, with bright green trim. In her book *Friends and Neighbors: A Pictorial History of the Town of Plattekill and Southwest Lloyd, Ulster County, N.Y.*, historian Shirley Anson writes, "It was stated in one of the early commissioners' reports that the school, housing eight grades, had the desks facing the walls and the children sat on benches around the room with the teacher centered in the middle along with the pot-bellied wood stove."

The small school contained a very active student population. Due to its proximity to the Plattekill Grange Hall on Church Street, students in the Prospect Hill School often participated in Grange activities, including debates and "temperance instruction" contests. During World War II, students at the Prospect Hill School formed a Stamp-Saving Club, collecting cancelled stamps that would then be sent to England, where the sale of the dye from the stamps benefited hospitalized children.

The Prospect Hill School was closed in 1942, at which point the younger students were sent to the Plattekill Elementary School while students in seventh and eighth grades attended the John G. Borden High School. The building was sold the following year and remodeled into a private residence. In 1955, former students and teachers as well as members of the Board of Education were invited by the owners of the former schoolhouse to revisit the Prospect Hill School for the first-ever alumni reunion as part of Education Week activities. Today, the former Prospect Hill School building still stands and remains in use as a private residence.

The Sylva School District No. 2 (also known as the **Caper Hill School**) was located near the present-day intersection of New Hurley Road and Route 32 in Plattekill. Because it served students from both the towns of Plattekill and Newburgh, it was known as a "joint district school." The school had one of the smaller populations among the common schools, with an average student body of twenty to twenty-five pupils. An inspection in February 1873 noted that "the scholars displayed a fair degree of intelligence."

Trustees Report – 1901

Amt on hand Aug 1st 1900

Supervisor	53.63	
Collector	48.54	
Total		102.17
Collected by Tax	174.52	
Public money	105.86	
Total		280.38
Total receipts for year		$382.55
Paid for teachers wages	260.80	
Repairing school house	47.44	
Balance on Chart	11.20	
Wood 8½ cord @ $3.50	12.25	
Sawing wood	1.90	
Wall paper	1.91	
Bunting to repair flag	2.00	
Other expenses Slack, chalk, Broom &c	1.97	
Cleaning school house	2.00	
Total Expenditures		$341.47
Bal on hand Aug 6 – 1901		$41.08

1901 Trustees Report for the Caper Hill School (later known as the Sylva School). *Courtesy of Historic Huguenot Street Archives, Mary Anne Brown Papers, 1867–1945.*

The Sylva School was quite active and hosted many events, such as dances and lectures, for members of the community. During the 1930s, students in the school were recognized for taking state-level prizes for their essays and posters promoting temperance. Like the students at the nearby Prospect Hill School, Sylva students were often involved in Plattekill Grange activities and contests. Each June, school would close with an athletic test, picnic and awards ceremony. At the ceremony, students would be presented with awards for penmanship, spelling, sportsmanship and "best garden." In order

Sylva School students pictured with teacher Mrs. Benedict, circa 1930. *Courtesy of the Moran family.*

to win a badge in the athletic contests, students would be required to climb a twelve-foot rope, throw a basketball and baseball for accuracy at forty feet, balance on a beam and complete a fifty-yard dash in eight seconds.

Because of its proximity to the Modena school, Sylva students were often transported to Modena for combined lessons and athletic events. Sylva had a boys' baseball team that regularly completed against Modena's team. The Sylva school closed in 1941 as a result of centralization, and most Sylva students began attending school in Modena. The school building no longer stands.

One of the most isolated schools in the town of Plattekill was the **Unionville** or **"Marlborough Mountains" School District No. 10**, which stood at the corner of Unionville Road and Lewis Lane in the town of Plattekill. An 1874 inspection report published in the *New Paltz Independent* describes the small school at the base of the Marlboro Mountains in the following manner:

> *Here, most of the land is rough and ledgy, and the people seem to be quite poor and live mostly in small, unpainted houses. The Unionville schoolhouse is a small building, and we found 23 students assembled. J. Howland Bull, of Delaware County, is teacher. The school is very backward, only*

two or three of the scholars being engaged in the study of geography and only one having gone farther than fractions in arithmetic.

The Unionville school housed students in grades one through eight. Students participated in a variety of clubs and activities, including "The Children's Stamp Club of Unionville." When the cornerstone was laid for the new Plattekill Elementary School in 1941, student Lorraine Wager represented Unionville at the ceremony. Unionville students contributed a piece of stained-glass windowpane from the Quaker Meeting House that once stood near the school. (The glass had been donated to the school by Mrs. Albert Klein, who lived in the former meetinghouse at the time.)

Unionville closed in 1941, and like the other neighborhood schools in that area of Plattekill, its students began attending the Plattekill Elementary School and John G. Borden High School. Today, the former school building still stands and is a private residence.

The hamlet of Modena had a schoolhouse as early as 1797, prior to the formation of the Town of Plattekill. The first **Modena School**, a former

An 1876 pay stub for teacher Frank Scofield, a teacher at the Unionville or Marlboro Mountains School in the town of Plattekill, signed by Town of Plattekill supervisor Richard Garrison. The pay stub shows that Scofield was paid a total of $131.52 for the period from November 15, 1875, to April 1, 1876—approximately $5.00 a week. *Courtesy of Shirley Anson.*

residence, stood just north of the modern-day intersection of Routes 44/55 and Route 32, on land donated by William and Catherine Drake. The school contained slanting desks and wooden benches on three sides of the room that faced the wall. The trustees of this school were William Thompson, Samuel Church and Silas Simkins. The trustees conveyed the school building and its property to one Peter Dougherty in 1812.

Another early school in the hamlet of Modena was a private academy run by John Cole. Cole established the academy around 1825 in the building that would later become the Modena Methodist Church parsonage, near the present-day intersection of Route 32 and Routes 44/55. (The academy building was torn down in 1935 and replaced by the parsonage that stands today.)

By 1825, a second one-room building, which came to be known as the **Modena School District No. 4**, was constructed in Modena just south of the present-day intersection of Plate Road and Route 32. An 1874 visit to the Modena School by county inspectors reported students in the school to be "quite well advanced," a notable achievement for a school that routinely housed forty to fifty students with one teacher. Other reports described the school as "not situated in a locality easily reached by rail or stage but… very pleasantly located" along the main road, with a fence and several trees. Younger students in the school were well versed in geography, grammar and arithmetic; older students "had gone as far as cube root" and were studying "Natural Philosophy."

The arrival of the railroad in 1888 forced a change at the Modena School. Surveyors determined that the school building sat roughly in the path of the new rail line and needed to be moved. The building was relocated to a site farther south. In the late 1920s, the need for a larger, more modern building was recognized, and so a new school was constructed by Charles Wells and his son, Floyd Wells. The new two-story school building was ready for occupancy by 1927.

Upon its opening in July 1927, a correspondent for the *Kingston Daily Freeman* noted that "the new school presents a splendid appearance with its new coat of paint." It contained "two classrooms, coatrooms and lavatories on the second floor, and a large basement auditorium and furnace room" and sat on a two-acre plot of land. The first teachers were Laura DuBois and a Mr. Snyder. The former schoolhouse was sold at public auction and remodeled into a private residence and later a small store and service station. Until it was sold, the previous Modena School was used for a short time by Modena students when they took their Regents Exams. (In later years, students would travel to Clintondale or Wallkill to sit for these assessments.)

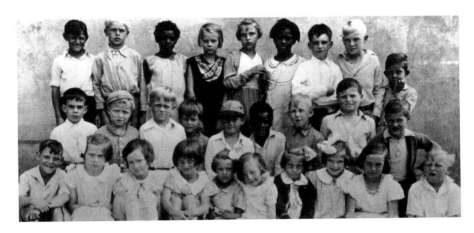

Modena School students, circa 1938. *Courtesy of Shirley Anson.*

Students in grades one through four were placed in one classroom, while students in grades five through eight were taught in the other room. The Modena School became part of the Wallkill Central School District on May 4, 1939, and was the last neighborhood school to remain open after centralization. Upon centralization, the building housed students in grades one through six with a principal and two teachers. Seventh- and eighth-grade students were bussed to the junior-senior high school in Wallkill.

By the 1940s, it was common for Modena School students to travel to the new junior-senior high school in order to use the auditorium for different programs. They would attend chapel in their own school every other Friday and participated in a number of activities, including Knitting Club, Dramatic Club and Tap Dancing Club. Given its proximity to the New Paltz Normal School, student teachers often worked at the school, and instructors from the campus would often bring groups of college students to observe the Modena School students.

Students attended elementary school in the Modena School until it closed in 1973. At that time, the building became part of a community project, as the Wallkill Central School District leased the building for the purpose of providing a home for the Plattekill Reading Center, Inc. Because Plattekill was one of the few remaining towns in Ulster County without a library, the Reading Center provided a place where volunteers could offer books to residents, provide a community meeting space and offer a variety of community services. The former Modena School would later become home to the Plattekill Public Library and Plattekill Senior Center, both of which still operate today in the same building.

Chapter 3

Town of Newburgh

Attending the Wallkill School District in the 1970s and 1980s made us fortunate to not only have fond memories of activities and friends but also many excellent and dedicated teachers. Not only did they educate us, but they also made us feel valuable and special. Our education at Wallkill inspired both of us to return and join the ranks of the many people whose commitment and caring helped make us the educators we are today.—Joseph Zupan, Wallkill High School Class of 1982, and Mary Paribelli Malfa, Wallkill High School Class of 1986, teachers at the Leptondale Elementary School

The first documented school in Leptondale was a one-room building on Quaker Street that served children in grades one through eight and stood a quarter mile north of the current site of the Leptondale Elementary School. (Today, that building is a private residence.) With nearly fifty students being instructed in the small one-room building, it was decided that a new school was necessary. Leptondale residents Alonzo Benedict, Ray B. Benedict and William W. Benedict were chosen to build the new school. Construction on the building "just off the North Plank Road, about one-eighth mile up Quaker Street" began in 1916 and was completed in 1917. The small school consisted of a single classroom, two cloakrooms, a basement and a hall and was known as the **Leptondale School District No. 7, Town of Newburgh**. The first teacher at the new school was Mabel Chamberlain.

The initial size of the building eventually necessitated that seventh- and eighth-grade students attend school at the Fostertown School in Newburgh, but an addition in 1933 allowed those students to return to the Leptondale building. From its initial design as a one-room schoolhouse, the Leptondale school grew large enough to provide services for students in grades one through eight with three teachers. In October 1938, by approval of the New York State Board of Regents, Leptondale School District No. 7 officially became a part of the Wallkill Central School District. Two teachers presided over the multiple grades until 1943, at which time seventh- and eighth-grade students went to the Wallkill High School. Once the seventh and eighth grades were housed elsewhere, a kindergarten program was added in 1947. The school in Leptondale School District No. 7 closed in 1959 after the new Leptondale Elementary School was built. The district sold the second Leptondale School and approximately an acre of land at public auction in November 1965.

Much of what is known about the **Forest Road School** is in great part due to teacher Kenneth Hasbrouck, who documented the history of the one-room schools built along present-day Forest Road in the town of Newburgh. In his *History of Forest Road*, Hasbrouck wrote of the first unnamed common school in that area, which was built of logs and heavy timbers in the early 1800s and used for both a schoolhouse and a Sunday school building. A second school was built sometime prior to 1859, near the present-day intersection of King's Hill Road and Rock Cut Road, and was known as the "Old Red schoolhouse" and the "Rocky Forest School." The school was moved for a third and final time to a site near its original location "about 50 feet south of the North Plank Road on the Rock Cut Road." The site was part of the Wygant family property and was deeded to be "used for educational purposes."

An addition was added to the new building, now known as the "Little White schoolhouse," as was a shed used by both the school and the church. Hasbrouck described the playground of the school as "unusually excellent... [consisting] of one-half acre of level, landscaped land bordered by beautiful old maple trees. In the center are two old-fashioned flowerbeds containing narcissus, iris and lilies-of-the-valley. Rose and lilac bushes grow along the east side of the playground...planted in honor of previous Arbor Days."

Prior to World War II, an active mother's group known as the Forest Road Community Club supported the school in various activities. One such activity was the creation of a Community Afghan for the Red Cross. When the United States entered the war, students in the school wanted to help

in some way and decided to learn knitting in order to create items for the Red Cross. The mothers' group taught the children to knit and follow patterns; the first student creation was the Community Afghan that was eventually donated to the war effort.

In 1939, the Forest Road School became part of the Wallkill School District but remained open into the 1950s. By 1943, the building housed students in grades one through six, while seventh- and eighth-grade students attended the Wallkill Central School.

The Savilton School (Town of Plattekill District No. 6) stood along today's State Route 32 in the town of Newburgh, near the southern border of Plattekill. In early inspection reports, it was referred to as "the school

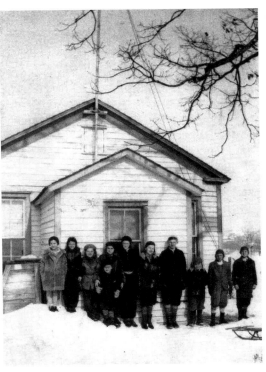

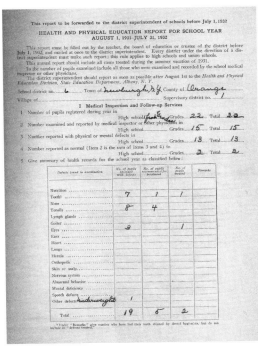

Top: An undated image of students outside of the Savilton School in the town of Newburgh. *Courtesy of Shirley Anson.*

Bottom: Health and physical education report for the Savilton School, 1932. As part of the school census process, teachers or trustees were required to fill out detailed forms, including information regarding student health, nutrition and any known "physical or mental defects." *Courtesy Wallkill Central School District Historical Archives.*

southwest of the Valley," "the Rossville School" or simply "Orange County No. 6." Like the Sylva School to the north, the Savilton School had students from both Orange and Ulster Counties and so was known as a "joint" district school.

As late as the 1930s, more than fifty students were enrolled in the school, with daily attendance ranging between twenty and forty-five students. The Savilton School was closed in 1941. The Wallkill Central School District retained ownership of the property until 1974, when it was sold at auction.

Chapter 4

Town of Gardiner

The Benton's Corners School was created circa 1850. In 1939, it was merged into the Wallkill School District. From the 1940s to 1950s, boys walking to school carried shotguns to hunt squirrels along the way, and students such as the Conner children—Thelma, Skeeter and Tom—took turns fetching water for the school from Miske's store, nearby at the corner.—Town of Gardiner *Historian Carlton Mabee,* Gardiner and Lake Minnewaska

[In the New Hurley School] *some of the desks were double seats, screwed to a board so they could be moved for easy cleaning. There was a piano, a blackboard on two sides of the room and a recitation bench. Some books were borrowed from the Walden Library for two weeks;* [teacher Hazel Ronk] *had to buy the workbooks herself. Flash cards were made from the dividers in Shredded Wheat boxes. There were times the school was very cold, so she took the children to her home to teach.—Elaine Terwilliger Weed,* One-Room Schools of the Town of Shawangunk, 1800–1943

When the Town of Gardiner was formed from the Town of New Paltz in 1853, the newly organized township boasted nine common schools, each of the one-room variety and some part of the joint district shared with the towns of Plattekill and Shawangunk. Two of those schools—Benton's Corners and New Hurley—would later be consolidated into the Wallkill Central School District.

The **Benton's Corners School, Town of Gardiner District No. 7**, also known as the Schoonmaker Neighborhood School, once stood

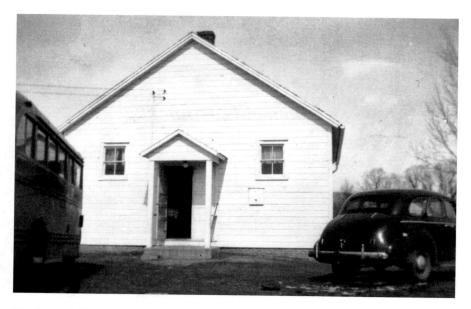

The Benton's Corner school, one of the last neighborhood schools to remain open after centralization. *Courtesy of Historical Huguenot Street Archives, Kenneth Hasbrouck Papers.*

near the present-day intersection of Routes 44/55 and Bruynswick Road. The first known school in that area was constructed on land donated by James Benton sometime prior to the Civil War. Historian Kenneth Hasbrouck wrote that it was known as the "Pink Schoolhouse" for many years, as it was painted with a mixture of colors left over from nearby houses (other histories indicate that the building turned a pinkish color after its original red paint faded). In 1880, another school building was erected on the same site. Later construction of the Minnewaska Highway (today's Route 44/55) forced the building to be moved approximately one hundred yards north of the original location.

Because of its rural location, most students who wished to continue their education beyond the eighth grade attended the New Paltz Normal School; following centralization, older students attended the Wallkill Central School. The Benton's Corners School was one of the last neighborhood schools to remain open after the creation of the Wallkill Central School District, serving students in the Wallkill District through 1956. The last teacher at the Benton's Corners school was local artist Leonard George.

The **New Hurley School**, first known as **Joint District No. 3 of the Towns of Plattekill and Shawangunk** and later as **Joint District No.**

12 and No. 6 of the Towns of Gardiner, Shawangunk and Plattekill, is unique in that the district was considered part of the towns of Plattekill, Shawangunk and Gardiner at different points in its history. The first school was located along the west side of the road that is the present-day Route 208. Built around 1800, the school at that time stood on the border of the towns of Plattekill and Shawangunk and was known as District No. 3—a joint district of the two towns.

Following the formation of the Town of Gardiner in 1853, the school became the joint Gardiner, Shawangunk and Plattekill District No.12. In the late 1800s and early 1900s, many older students in this area actually attended school in the town of Lloyd, as it was easier to ride the milk trains to Highland than to walk miles to the nearest school at New Hurley or Sylva in Plattekill. The train would stop at New Hurley and continue to Modena, Mowbray Crossing (Alhusen Road), Elting Crossing (Hurds Road) and then the Clintondale Station before discharging students at Pratt's Crossing in Lloyd, where they would walk to Highland High School on Main Street.

The building of the Catskill line of the New York City Aqueduct forced many changes in the hamlet of New Hurley, including to the school, as the new line ran directly through the schoolhouse property. In 1908, ownership of the school building was taken over by the Catskill Aqueduct Company, and classes were held

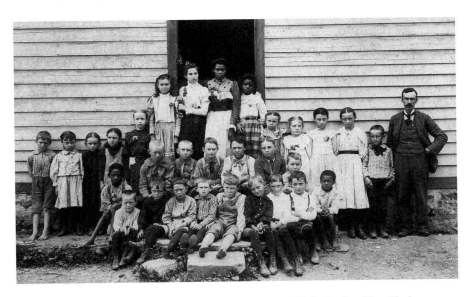

Teacher Byron J. Terwilliger with students at what is most likely the first New Hurley School. Notice the number of children who were barefoot. *Courtesy of Historic Huguenot Street Archives, Byron Terwilliger Papers, 1867–1962.*

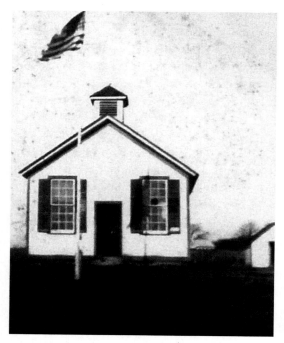

The second New Hurley School. *Courtesy of the Historical Society of Shawangunk and Gardiner.*

in a vacant home owned by a Mr. Tompkins for a period of time. (A correspondent for the *Kingston Freeman* noted, "The walls are quite solid yet" on the old house, the best that could be said of the temporary school building.) That winter, taxpayers met to choose a site for the new schoolhouse. Money for the building was donated by New York Water Works, and a building was constructed across the road from the original site. By 1910, students were attending school in the new building, now situated in the town of Plattekill. (It was still a joint district of the three towns, by this time referred to as District No. 6.) The building featured a cloakroom, a pot-bellied stove, a piano and, by the late 1920s, electric lights.

Residents voted to become part of the Wallkill School District in 1938, a move that was approved by the New York State Board of Regents. In her book *One-Room Schools of the Town of Shawangunk*, Elaine Terwilliger Weed notes that a lack of modern amenities forced the closure of the New Hurley School and the end of the one-room school era in the hamlet of New Hurley, as "many of the children whose fathers worked at the [Wallkill] prison did not like an outside toilet; these parents worked to get the school closed." The vote to finally close the school came in 1941, and the twenty-eight remaining students were bussed to the modern Wallkill Central School building—with its indoor plumbing—in the hamlet of Wallkill. Throughout its history, a total of thirty-one teachers taught in the one-room New Hurley School. Ruth Dylewski was the last teacher, and Nicholas T. Cocks, a one-time student at the New Hurley School, was the last trustee of the district. The former New Hurley School building was sold as a private residence that still stands today.

Chapter 5

Town of Shawangunk

The one-room Bruynswick School had a janitor who would sweep the floor and stoke the fire. The seats were on runners so they could be pushed out of the way for cleaning…one student would be assigned to go out and raise the flag each day. Students in a one-room schoolhouse had a complete education, because all day they would always hear the lessons being taught to each grade level around them. You wouldn't ever speak back to a teacher, and chewing gum was not allowed—both would earn you a smack on the hand from a teacher. There was an outhouse that every Halloween got turned upside down. Children would play games like tag and ring-around-the-rosy during recess, and the teacher would ring the bell to bring everyone back inside.—Elaine Terwilliger Weed, Bruynswick School student, Wallkill High School Class of 1942

Various historians have noted that education was an early tradition in the town of Shawangunk, with the New Hurley and Shawangunk Reformed Churches playing a leading role. The ministers of each of these churches would conduct classes for students as young as four and as old as twenty-one. The town of Shawangunk contained at least thirteen neighborhood schools, although following centralization, several of them became part of the Valley Central or Pine Bush School Districts. Six neighborhood schools—Bruynswick, Galeville, Hogaburg, Plains Road, Rutsonville and the Wallkill or "Basin" School—eventually became part of the Wallkill Central School District.

The first **Bruynswick School, Shawangunk District No. 8**, was located on Bruynswick Road near the present Shawangunk Valley Firehouse. There is little recorded information about this early school, although Nathan Sylvester, in his *History of Ulster County, N.Y.*, indicates that by 1820, a school existed near Bruynswick, with "a man by the name of Jackson" serving as teacher. A second school building was constructed in the same area in the early 1800s. An early inspector's report describes the Brunswick students as being "admirable" readers. The account also noted that while the inspector could not speak very highly of the students' knowledge of arithmetic or proficiency in grammar, at least the building contained "excellent desks." Because it stands along the border of the town of Gardiner, it has in the past been included in the histories of that town.

One noted teacher at the Bruynswick School was P.N. Mitchell, later a teacher and a principal in the Clintondale School (on the border of the towns of Lloyd and Plattekill) and author of an early history of the hamlet of Clintondale. Another instructor, Byron J. Terwilliger, was later a teacher at the New Paltz High School and a local historian best known for his book *Old Gravestones of Ulster County, New York* (in collaboration with J. Wilson Poucher). Sally Meredith was the last teacher at the Bruynswick

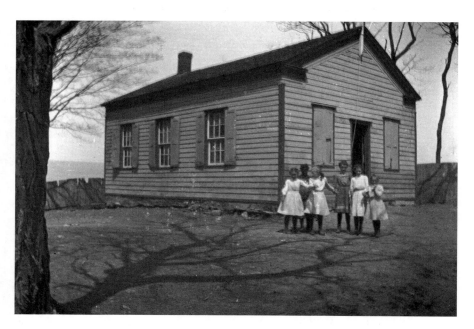

Students outside the one-room Bruynswick School District No. 8 of the Town of Shawangunk. *Courtesy of Historic Huguenot Street Archives, Byron Terwilliger Papers, 1867–1962.*

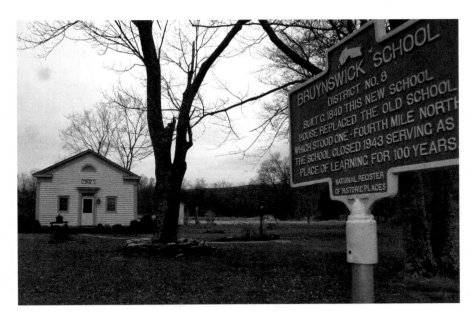

Today, the Brunswick School District No. 8 is a private residence and is listed on the National Register of Historic Places. *Authors' collection.*

School, which closed in 1943. During that school year, only fourteen students attended school at Bruynswick.

It has been written in other histories that many of the trees that still stand on the property were originally planted by Bruynswick students during Arbor Day celebrations. As part of the celebrations, students would write their names on slips of paper that would be deposited into a glass jar embedded into a tree on the property. Today, the building is a private residence. In the fall of 2000, the home was added to the National Register of Historic Places.

The **Galeville District No. 13** of the town of Shawangunk contained a one-room schoolhouse located on Albany Post Road in the hamlet of Galeville, near the present-day intersection of Albany Post Road and Long Road. The Galeville School, like many others of the era, had separate entrances and cloakrooms for boys and girls and a potbellied stove that required students to help carry in wood. Sitting on nearly an acre of property, the schoolhouse also boasted "two outhouses, one for the boys and another for the girls. A solid wooden fence separated them. Both outhouses were 'three holers' and had three holes of different sizes."

The Galeville School was an integral part of a neighborhood that once included a blacksmith shop, store, newspaper office, hotel and post office.

The hamlet also served as the stagecoach stop for the Wallkill village prior to the coming of the railroad in 1869. Because Galeville was such an active community from the late 1800s through the 1920s, the school had a high enrollment, with close to forty students being taught by one teacher. Many of the students had to walk across the covered bridge at Galeville to reach their school each day.

Galeville students were quite involved in the community. They raised funds to sponsor a traveling library from the New York State Education Department and organized a Health and Safety Club and a Sewing and Homemaking Club. During World War II, students pieced together quilts to raise money for the Red Cross and held scrap drives. A popular activity for students in the school was watching airplanes at the nearby Galeville Airport. Each December, the school would host a Christmas pageant to which community members were invited. Students would decorate a

Mrs. Elaine Terwilliger Weed, April 2013. Weed's research into one-room schoolhouses in the town of Shawangunk began when she came across teacher attendance books, such as the one she is holding, that were going to be thrown out until she saved them. *Authors' collection.*

Christmas tree and would wear their best clothes to school on the day of the pageant. They would perform Christmas songs and poems for the audience.

As businesses left the hamlet, enrollment declined sharply, with fewer than a dozen students in attendance some years. Teacher Vivian McLean was in charge of the last class at the Galeville School, which closed in 1943. Today, the former schoolhouse is a private residence.

The **Hogaburg School District No. 6** (also referred to as "Hoagberg," "Hogabergh" and "Hoagerburgh" in various histories) was located on Hoagerburgh Hill Road and Old Fort Road in the town of Shawangunk. Early maps of the town show a school district existing in the area as early as 1858. The school was recognized by school commissioners as having students who did well "in ciphering interest" and in analysis and who were "well-advanced" in mental arithmetic. Hogaburg consistently had one of the smallest student populations of the neighborhood schools, averaging a daily attendance of only twenty students. Inspections in the early 1900s pointed out that the Hogaburg School was utilizing modern technology unknown to the other neighborhood schools at the time—two indoor chemical toilets rather than the traditional outhouses utilized by most schools (and private residences) in the area.

By the 1940s, there were fewer than twenty students attending the school. Mae Furman, who taught in the school for eighteen years, was the last teacher at Hogaburg. The Hogaburg School closed in 1943 and is currently a private home.

The **Plains Road School District No. 2 of Shawangunk and District No. 9 of Newburgh** was a log structure originally located near the intersection of Plains and Reservoir Roads. The first building was constructed in the early 1800s, with another larger building taking its place around 1843. Residents of the two districts held a special meeting on October 16, 1843, and voted twenty to one to construct a new school building with dimensions of twenty by twenty-six feet "on the site of Daniel Garrison and Daniel Merritt on the east side of the Plain Road joining the road."

Daniel Merritt and John S. Gale were appointed as building inspectors for the new school. Gale was also chosen to build the new schoolhouse, while Merritt was appointed trustee for three years. The cost of construction was $235, and residents had also voted to set aside $22 for the teacher's annual wages. The old school was sold at auction to John Wright for the sum of $13. By 1847, the district was known as the Joint School District No. 2 of Shawangunk, Newburgh and Plattekill. (Plattekill was periodically added to and dropped from the name through the 1920s.) A fence was constructed around the property in 1861.

By the 1870s, eighty-three children of school age were listed in the district register, with the typical school year being 193 days in length. An average of twenty-two students attended school each day. The district librarian turned over his books to the school, making the Plains Road School one of the first in the area to contain a small library within the school itself. The schoolyard was large enough to have a baseball diamond that was used by students in both the Plains Road and New Hurley schools. The building was also used for religious instruction on the weekends.

In October 1883, a vote was held to decide whether to construct a new schoolhouse; six residents voted for a new school, while thirty-two voted against. Instead, it was resolved that a twelve-foot addition be constructed on the existing school. Given the large number of children attending school at that time, the vote was reconsidered, and a month later, on November 8, 1883, residents authorized a new schoolhouse to be built on the site "of such dimensions as will accommodate the children of this District in a healthy and comfortable manner and in such a way as will be in all respects best adapted for the advancement of the children in their studies." The new building was thirty-six by twenty-two feet, with a twelve-foot ceiling, six windows and a proper chimney. The interior was wainscot, with Georgia pine flooring, while the exterior boasted a vestibule and a cupola. The former schoolhouse was sold at auction to D.B. DuBois. An addition to the 1883 school was completed in 1892.

In her book *One-Room Schoolhouses of the Town of Shawangunk*, historian Elaine Terwilliger Weed wrote that one Plains Road teacher, Bessie McHugh, was especially well known. McHugh would ride her bike several miles from the hamlet of Wallkill to teach school each day. After teaching in Hudson Valley and Pennsylvania schools for more than sixty years, she later became an assistant to the New York State Commissioner of Education.

The Plains Road School closed in 1946 following a petition made by taxpayers in the area to close the school and send all students to the Wallkill Central School. At least thirty-three teachers instructed at the Plains Road School throughout its long history; Mrs. James Crowell was the last. The building still stands today and is used as a machine shop on the Garrison property.

A school existed in the hamlet of Rutsonville, on the border of the towns of Shawangunk and Gardiner, for more than one hundred years. The **Rutsonville School**, or **Rutsonville Corners School, Town of Shawangunk District No. 9**, was constructed near Tillson Lake. At times, the building was overcrowded. Several reports listed an average of

fifty students to one teacher, with peak enrollment in the 1870s, when sixty-five students were on the roll under the direction of teacher Susie Dickinson. Visiting commissioners reported that this was "too many for one teacher."

The schoolhouse had a small belfry and a school bell (the latter remained on the property for many years after the building closed). It also had a small museum created by students to house the rocks and stones they collected from the school grounds and field trips to local sites of interest. Students in the Rutsonville School participated in activities such as a stamp club and a "Good Writers Club." Following centralization, students frequently contributed articles to the district's *Wallkill Blue and White* newspaper.

When the 1942–43 school year opened, the Rutsonville School had only eight students. The school closed midway through the school year, on March 28, 1943, and on March 29 Rutsonville students started attending the new elementary school in the Wallkill Central School building (today's John G. Borden Middle School). The former schoolhouse became a private residence, which later burned down.

Within the present-day hamlet of Wallkill, there were at least three one-room schoolhouses. The first documented building was known as the **Basin School**, or the **Wallkill School, Town of Shawangunk District No. 5**, located on the "Galeville Road" (present-day River Road). Originally constructed around 1830, the school was part of the Lucht farm along the

A postcard view of Lucht's farm, where the first known schoolhouse in the hamlet of Wallkill was built. *Courtesy of the Historical Society of Shawangunk and Gardiner.*

Wallkill River on Bruyn Turnpike. According to early histories, the school was closed in the winter, as moisture from the nearby river would cause the school doors to freeze shut.

A second, larger building was built in later years just across the Wallkill River. The two-story school stood "on the west side of the Wallkill River on a knoll just about 50 feet south of the old covered bridge." This building contained two classrooms for students in grades one through eight, with Principal Everett Cameron teaching the older grades. A commissioner's report in the 1870s stated that the schoolhouse was in poor shape, unfit for its purposes, and suggested that "since it was a wealthy locality, they could afford to put up two schools." The third school building, constructed on Bridge Street in the hamlet of Wallkill, ultimately became known as the Wallkill Union Free School.

Chapter 6

"Electric Lights and a High School": The Wallkill Union Free School

A meeting of the voters of this school district has been called for March 25 to consider the change to a union free school. It is to be hoped that it will be carried, as our building in its present condition is worthy of an advance, and it is handled by instructors capable of doing more advanced work, to say nothing of the benefits to be derived in more ways than one.—Unnamed Wallkill correspondent to the Kingston Freeman, *March 11, 1908*

Resolved, that a Union Free School be established within the limits of School District No. 5, joint towns of Shawangunk and Montgomery, counties of Ulster and Orange, in conformity with the provisions of Title 8 of Chapter 556 of the laws of 1894, known as the Consolidated School Law, and the acts amendatory thereof.—Proceedings of the Board of Education of Shawangunk School District No. 5, March 25, 1908

Wallkill's first high school started as the two-room **Basin School, District No. 5 of the Towns of Shawangunk and Montgomery**, on Bridge Street in the hamlet of Wallkill. The first building on Bridge Street was built sometime in the late 1800s or early 1900s, with another building replacing it in 1907. In addition to the elementary grades that had been contained in the earlier school, this new building, constructed of brick and wood by contractor J.D. Van Leuven, contained enough room to be able to house high school classes. The first principal was J. Edmund Graham.

In 1908, voters in the district met to discuss the formation of a union free district, which would allow the common school to add high school courses. By March of that year, residents voted "by an overwhelming majority" in favor of becoming a union free district, governed by a board of education rather than the previous common school trustee system. By state education law, the union free school needed a board consisting of three to nine members. An item appeared in the March 28, 1908 edition of the *Kingston Freeman* that detailed the historic vote:

> *The district meeting held in the school building on Wednesday evening looking toward the change of the school district to a union free school, with an advanced course, brought out a goodly number of our best and most interested citizens. Dr. Millspaugh was chosen chairman and M.J. DeWitt, secretary. After the call had been read and the object and conditions fully made clear by the remarks of Mr. Case from the state department, a ballot was taken and the question carried by an overwhelming majority in favor of the change. It was decided that the board should contain five members, and the election was held at once with the following results: F.J. Wilkin and W.S. Thompson for one year; Mrs. E.L. Borden and Mrs. E.S. Roosa for two years; and Nelson Smith for three years. The board is a strong one and have the interest of the community at heart, and we feel confident that another upward tendency has been accomplished. Electric lights and a high school, both within the past two months. Surely things are coming our way once in a while.*

The building came to be known as the Wallkill Union Free School—or "the little grey schoolhouse under the trees" among area residents—and served students in grades one through eight, as well as two years of high school for students between the ages of twelve and eighteen. Eventually, the curriculum was expanded to allow for instruction in grades one through twelve. To make room for an ever-increasing population, the original building was enlarged in 1908 by removing the belfry and adding a second story. That same year, the school caught fire and was severally damaged; while the building was reconstructed, students attended classes in the town clerk's office. Subsequent additions were built in 1912 and 1914, and eventually the schoolhouse contained seven rooms. In addition to several teachers, the Union Free School had a principal and an assistant, both of whom also taught classes; a janitor; and a full-time clerk. (The clerk's salary was initially set at twenty dollars a month, while the janitor,

A 1912 postcard view of the Wallkill High School. By this time, a second story had been added to the school. Teacher Ethel Cashman wrote on the back, "There is lots to tell you about school but haven't time!" *Authors' collection.*

who was charged by the Board of Education to discipline students before and after school in the absence of any teachers, was paid twenty-five dollars a month.) The first class to graduate was the Wallkill Union Free High School Class of 1913. The graduating class had just two students: Margaret Roosa and Theodora Smith.

The Wallkill Union Free High School featured sports teams, including a boys' baseball team that would play against the nearby Walden High School team. The Wallkill students maintained a fierce rivalry with Walden High School that was often reported in the newspapers of the day. One memorable event revolved around the 1916 presidential election, with Wallkill students declaring themselves Democrats in favor of incumbent Woodrow Wilson and Walden students soundly in favor of Republican candidate Charles Evans Hughes. When the results of the election filtered in, Walden students marched the four miles to the Wallkill High School with the intent of disrupting classes there for the day. The marchers came prepared with "horns, rattles, drums and brooms," as well as their own Walden High School Fife, Drum and Bugle Corps. Wallkill students ignored the hubbub and continued their lessons that day, but the Wallkill Board of Education entered a formal complaint with the Walden Board of Education.

The construction of the Wallkill Firemen's Hall next door to the school provided more room for student activities. Students often used the hall for games, to perform plays and to hold frequent dances. Commencement exercises were held in the Wallkill Reformed Church. Students who lived in the village usually walked home during their lunch hour, but students from outside the village would carry their lunches in bags or pails and eat in the principal's office.

In 1912, the Board of Education began reviewing the district boundary lines, which extended into the St. Andrews/St. Elmo District in the town of Montgomery. Students living in that area had the choice of attending either the Walden High School or the Wallkill Union Free School. Despite intervention by the New York State Department of Education, the lines between the two districts remained undefined for many years after.

A vote was taken in September 1916 to decide whether to raise $30,000 for the purpose of building a new high school. The money would be collected in taxes over a period of two years, with plans to begin building by early 1919. Residents voted 46–22 to approve the new high school. The lengthy time period gave the Board of Education ample time to investigate the exact sort of high school they wanted to erect in Wallkill. For more than two years, they met with architect George Lowe and studied plans used by "model

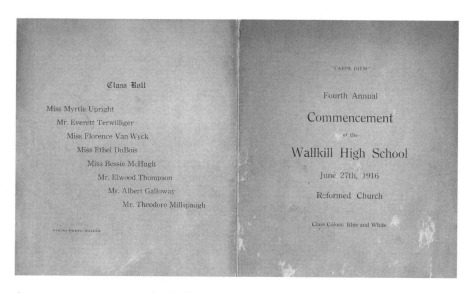

A commencement program for the Fourth Annual Commencement of the Wallkill High School. Large-scale school activities such as this were held in the nearby Wallkill Reformed Church. *Courtesy of Wallkill Central School District Historical Archives.*

schools" around the country. They voted to choose a site rather than the one currently being used, as they felt a new school needed ample property for future expansions. World War I brought a halt to many of the plans so carefully laid out by the Board of Education, as the skyrocketing costs of supplies and a shortage of skilled laborers put a stop to much of the construction being done in the area. Further complicating the matter was architect Lowe's assignment to the U.S. Navy. He was unavailable to work with the district again until late 1919.

By 1919, the school housed fifty-two students taking high school courses, forty-four students in grades seven and eight and sixty-seven students in grades one through six. Most students were from the towns of Shawangunk, Gardiner and Plattekill, but a great number of students came from places as far away as Monticello, New York, and Danbury, Connecticut, and boarded with village residents in order to earn a high school academic degree. With enrollment increasing, the time had come to make final decisions regarding what would be best for the students of Wallkill and the surrounding neighborhoods. It had become apparent that the former Basin School could no longer meet the needs of so many students, and so the Board of Education moved forward to focus on building a high school large enough to accommodate at least two hundred students.

The Board of Education, District No. 5 of the Town of Shawangunk, had one distinct advantage over other common schools in Ulster County facing the same question of how to provide the best education for an ever-increasing number of students—the foresight and generosity of the Borden Family.

Part II

The Borden Legacy

Chapter 7

The Borden Family

To make two blades of grass grow where but one grew before.
—John G. Borden

It is late summer in the hamlet of Wallkill, located in southeastern Ulster County in New York's Hudson Valley. It is still a relatively quiet hamlet, where you can hear the crickets chirp as the warmth of the summer sun fades. A cool breeze begins to descend into the valley as cows graze lazily in the last hours of sunlight, their tails lazily swatting at flies. As the breeze picks up, the aroma of fresh-cut hay circulates over the main road that divides the hamlet…a hamlet carefully and almost completely planned by one man.

Gail Borden Jr. was born on November 9, 1801, in Norwich, New York, and by 1829 was living in Texas. Not only was he was destined to change the life of Americans with his inventions such as the Lazy Susan, but subsequent generations of Bordens would also change the life of a small village in the town of Shawangunk—a town Gail Jr. would never see during his lifetime. It is here that John Gail Borden made his home and built a model community in the town of Shawangunk. By 1866, Borden Condensed Milk and the hamlet of Wallkill would be forever linked in history.

Upon entering the hamlet of Wallkill, residents and visitors alike are greeted by the happy face of the Borden mascot Elsie the Cow, an iconic symbol from the 1930s. However, Borden Condensed Milk was not invented in the hamlet of Wallkill, as many people commonly believe. Its origins can

be traced to Burville, Connecticut, with Gail Borden Jr. In fact, the business was not called Borden at all—that would come later.

Gail Borden Jr. spent his entire life hoping to better the lives of Americans at a time when their diets were greatly limited due to a lack of refrigeration. One of his goals in life was to find a way to keep foods, especially milk, from spoiling. The company history relates that the impetus for Borden's invention came while he was on his way back to the United States from an 1858 trip to Europe, where he was showcasing an invention for meat pies that did not spoil. It was while on a boat that he had the misfortune of witnessing "several children die from drinking contaminated milk." He became determined to find a way to keep milk from spoiling.

One source believes that his idea for inventions started around 1840. Prior to that, Gail Borden had a successful career as surveyor, having created the first topographical map of Texas and founded a newspaper called the *Telegraph and Texas Register*. His idea for making a better condensed milk was built upon his earlier invention in the 1840s for the "meat biscuit which was made up of dehydrated meat and flour." It never took with the public even though it was recognized as a great invention for the army. He capitalized on his future invention when he saw a contraption, known as a vacuum pan, used by the Shakers. They did not use these vacuum pans to make evaporated milk but instead when they were making preserves from harvested fruit.

Borden felt that he could use a variation of this technique to make milk safer and "discovered he could prevent milk from souring by evaporating it over a slow heat in the vacuum. Believing that it resisted spoilage because its water content had been removed, he called his revolutionary product condensed milk." What had in fact prevented spoiling was the heating of the milk, which killed the microorganisms. After receiving a patent, he decided to open up a small plant in Wolcottville, Connecticut. His new idea was anything but successful, and it seemed that it would not catch on with the public. Gail Borden again relocated, this time to Burville, Connecticut, and according to the company history, he named his business Gail Borden Jr. and Company. The idea of milk in a can still did not prove popular with the American public. However, his fortunes would change after a meeting with a future partner who had experience in the food industry and was able to market the product properly.

According to the company history, Borden met Jeremiah Milbank, a wholesale grocer, banker and railroad financier, in 1858, and the two men formed a partnership that same year. They decided to change the name from "Gail Borden Jr. and Company" to the "New York Condensed Milk

Company." The partnership could not have been better timed, as it came during a period in which there was increased scrutiny into what was in the food people were eating. The public, in short, was demanding not only access to fresh water but also fresh milk. Early muckraking journalists began exposing what was actually in the food that people were eating and in the milk they were drinking. Sometimes the biggest threat to life was not microorganisms but could include chalk or other foreign substances that made people sick or, in some instances, killed them. The demand for fresh milk was filled by Borden and Milbank's new company, which promised a quality product, free from contaminants. If this partnership moved his business toward success, the war clouds on the horizon in 1860 would greatly benefit the New York Condensed Milk Company.

Gail Borden Jr. married three times and had seven children, one of whom was John Gail Borden. It was this son who would follow his father into the condensed milk business. He even attended college in an effort to attain a business degree to help manage the family business. However, his education would be interrupted by the war.

When the Civil War started, John G. Borden was almost eighteen years old. It is believed by some sources that he was sympathetic to the Southern cause; however, there is no evidence to indicate this. This belief was in part because he had been born, in 1844, and lived part of his life in Texas before moving north at the age of thirteen. The elder Borden was no friend of slavery. Joe B. Frantz, in an article for the Texas Historical Society, writes: "In 1822, he was a principal figure in rescuing a freedman from rustlers." Gail Borden would go on to found a freedmen's school in Texas, where he spent his winters, as well as "a

John Gail Borden (1844–1891), the son of Gail Borden Jr., inventor of condensed milk and the father of Marion Borden. Borden bought the land that would become Home Farm and was later honored as the new high school's namesake. *Courtesy of Historical Society of Shawangunk and Gardiner.*

Sunday school for black children." Meanwhile, the United States government faced the issue of providing enough provisions for the Union troops. The elder Borden's condensed milk business caught their eye, and they contracted out for the condensed milk to be provisioned to the Union army.

John G. Borden decided to join the Union army, enlisting in the 150th Regiment in Amenia, New York, according to regimental rosters. John G. enlisted on September 5, 1862, to serve three years and was mustered in as sergeant, Company A. He was promoted to second lieutenant that same year and eventually transferred to Company D, of the 47th Infantry. Army life did not suit John G. Borden, who soon succumbed to a serious illness. This illness, which is not known, weakened him for the rest of his life and eventually led to an early death from "dropsy," better known today as edema. He was discharged on February 12, 1864, with regimental records stating that he was "discharged for disability."

The elder Borden and his company made a fortune with the army contract. Their first logo was not Elsie the Cow but a very patriotic American bald eagle. The company continued to expand into fresh milk, butter and other dairy products. Gail Borden died in Borden, Texas in 1874, leaving his business to his son John G., who became the company's second president.

As early as 1866, John G. Borden wanted to "establish a farm and a model community near a large city." It made sense that the city would need to be New York City. After all, it was where a large part of the Borden fortune originated. New York City was also hungry for fresh food and milk. After looking for a long period of time, Borden found the town of Shawangunk in 1881, gaining a special interest in an area known as the "Basin." The Basin occupied the area where the present-day hamlet of Wallkill is located. There Borden purchased "the Andrews farm and about 200 acres of prime farmland" sitting on a high knoll overlooking much of the Basin. Borden, whose family eventually included his wife, Ellen, and four children, Marion, Lewis, Gail and Penelope (known as Nellie), chose this location in part because it was near railroad and water routes. Borden came up with the idea to establish an ideal location for "a home, or a park, a resting place, a place of retreat from business and possibly a place for foreign dignitaries to visit."

The heart of the property was old Hasbrouck land that had been settled by Cornelius Hasbrouck, grandson of Abraham Hasbrouck, a patentee of New Paltz and the brother of Colonel Jonathan Hasbrouck of Newburgh. Borden commenced quietly buying up large parcels of land in and around the Basin until 1890, at which time he had accumulated some 1,500 acres of prime land. He went about "improving the lands on his farm and those in

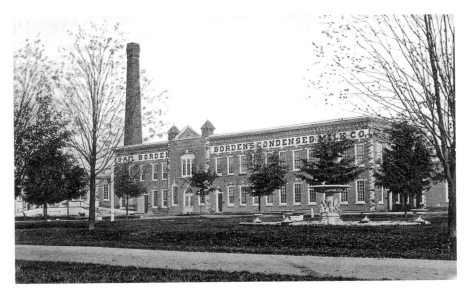

A postcard view of the Borden's condensed-milk factory on the Wallkill-Walden border. Once the headquarters for the company, today it stands in ruins. *Authors' collection.*

the village." He built "new roads and lined them all with maple trees; he also lined the public roads that ran through Home Farm." Borden envisioned large herds of milk cows and realized that his state-of-the-art factory would need more water than the property currently contained. At this point, he simply commissioned that seven lakes be added to his properties. One source writes that a pond was created near New York Condensed Milk Company's condensery. These ponds could also be used to harvest ice to store in the icehouses in order to keep the milk from spoiling until it could be canned. In a January 1922 issue of *Breeder and Dairyman*, it was reported that once the milk, which was 4 percent milk fat, was bottled, it was covered in crushed ice in order to keep it from spoiling. It would then be shipped to New York City. Borden's lands "eventually included barns, gristmills, woodlands, orchards, vineyards, pastures, parkland, tenant houses, paved roads, a large wind mill as well as a condensed milk factory" in order to supply New York City.

By the time John Gail Borden died in October 1891, after years of failing health, he had "developed an entire community, down to the streets, provided decent jobs to over 200 employees" in the village he named Wallkill. There were calls to name the hamlet after Borden because the name of his farm was "Borden's Home Farm." However, he opted instead for the name Wallkill, for the river that flowed through the hamlet.

It would have made sense to call what is today the hamlet of Wallkill the village of Borden or Bordentown, because the family owned just about everything in Wallkill. In fact, Mr. Frank Mentz, in his *Recollections of an Old Timer*, a remembrance of his childhood recorded in 1967, attributed the way the hamlet evolved to the Borden family. They quite literally created a town, and laid it out parcel by parcel. Mentz remembered that they "had the entire land east of the railroad laid out in building lots with wide streets, such as Lavoletta Street, which is a double street." There were also plans to create a cemetery on Bona Ventura and First Street near the present-day Town of Shawangunk Police Station that seemed never to have materialized.

John G. Borden extended his vision of park-like surroundings to the people who worked and lived around his Home Farm. He included two parks that still exist in the hamlet today. The building where the firehouse stands (which he envisioned for a bank) was also given to Wallkill. Finally, Mr. Borden envisioned an area of Wallkill that would be commercial in nature. Mr. Mentz believed it to be where Fair Rite is today. John G. Borden would not see his ultimate dream realized. When he died he was still far from completion of his village. Borden's vision was not entirely lost, however, as his work would be continued by his daughter and widow.

When John G. Borden died in October 1891, he was vacationing in Florida, where he retreated in the cold months because of his poor health. His body was returned to his beloved Home Farm, where he was buried on his favorite part of the farm. His wife, Ellen, continued to donate money and time to the schools in the area, eventually becoming a member of the Board of Education for the new Wallkill Union Free High School District No. 5. She helped to outfit several classrooms in the new buildings and would make special trips to visit parents who could not afford to purchase school supplies for their children. It is Marion Borden's impact on the village, however, that is still felt and seen today.

There is no doubt that Marion grew up hearing stories about the good deeds of both her father and grandfather. One such enduring story involves what locals originally called the "colored cemetery," which sits at the junction of Routes 208 and 300 on a small bluff guarding one of the many entrances to the farm. Supposedly, while serving in Civil War, John G. accredited the saving of his life to an African American soldier. He lost track of this man but searched for him for a good part of his life. When he finally located the man and his family, Borden was already living in Wallkill. He brought the man who saved his life and his family—as well his extended family—and had them live at Home Farm, where they were taken care of by the Bordens

for the rest of their lives. When a family member died, they were buried in that small burial ground. It is important to point out that Dr. A.J. Williams-Meyers, in his book *Long Hammering: Essays on the Forging of an African American Presence in the Hudson Valley to the Early Twentieth Century*, believes this burial ground to be an old slave cemetery.

Marion Borden was eight years old when her father died, too young to take the reins of the business. However, by the time she was twenty-one, she was firmly in control of the family business in Wallkill, which included five farms in the United States and Canada. She was chosen because of her "contacts with the farm and its management." She would retain this position until her death in 1930.

Like her father, Marion believed in social responsibility, and her contributions to Wallkill, like her father's, still stand out today. She carried on John G. Borden's legacy by creating a good working atmosphere for the company's employees and by providing them decent housing for little or no cost, decent work conditions and, most importantly, decent pay. These community minded people bucked the excesses and abuses of the period when workers were seen as little more than commodities to be exploited for their work and discarded when no longer useful. The Borden family subscribed to the early tenets of the Progressive Era that held with money came certain responsibilities toward those less fortunate.

Marion Borden was born on March 9, 1883. Her early life was not an easy one. It is true she was born to privilege and wealth, but she was also described as a sickly child "who had some trouble walking" due to the fact that she had contracted polio, a dreadful childhood disease that frequently left children disabled. In the history of Camp Wendy, a Girl Scout camp that Marion Borden was instrumental in creating, Marion is described as "having a lonely childhood." It is because of her disability that she attended a different school than that of her brothers and sister. They went to "the Old Bridge Street School, with its two stories of classrooms," while Marion was driven to the one-room St. Andrews/St. Elmo school several miles away in Walden (but still on property owned by her father), as it "was deemed easier for her to get to each day" and ultimately easier for her to participate in all school activities.

In the first decade of the twentieth century, the New York Condensed Milk Company had already changed its name to the Borden Dairy Condensed Milk Corporation. It is also during this time period that Marion met her future husband, a shoe salesman from Newburgh named George E. Halliday. Halliday was born in 1874 in Dutchess County, New York. Russell

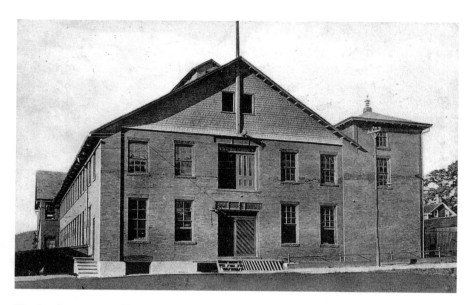

The hat factory owned by George Halliday and in which he died after coming into contact with a high-voltage wire at the factory. *Authors' collection.*

Headley, in his *History of Orange County, New York*, writes that George married Marion Borden in 1907. They are listed in the New York State Census for 1910 as having been married two years and living on Home Farm along with Marion's mother, Ellen L. Borden, who would continue to live with her daughter until her death in 1927. The Hallidays managed the farm, which by 1922 had two herds of cows—"90 Holsteins and 60 Jerseys."

Marion's farm was one of the largest in Ulster County. Until 1900, she had lived in her father's old mansion. Perhaps wanting a newer style home or one that at least reflected her station in life, she commissioned a new home to be built in 1900. It would be completed in 1906 and would eventually have electricity generated from its own power plant. There was enough electricity generated to also illuminate the village of Wallkill. The electricity was for her mansion and factory and later for the hat factory she had created in town for her husband to run. These early efforts are recognized as the beginnings of another large company in the area that is still in existence today—Central Hudson Electric and Gas. A 1908 announcement of for the collection of taxes in the school district noted that taxes to be collected that year would total $4,300, nearly half of which would be paid by Borden holdings, including the Borden Condensed Milk Company, Ulster Hat Company and Borden's Home Farm.

Marion Borden, second from right, on the porch of the mansion she had built in 1900 and finished in 1906. It was the first structure to have electricity in Wallkill. *Courtesy of the Historical Society of Shawangunk and Gardiner.*

Marion Borden Halliday was also involved in many areas of public life in Wallkill. She became a Board of Education member for Union Free School District No. 5 in the town of Shawangunk in 1918. In fact, many of the district meetings were held in her mansion. When it was decided that there was a need for a central high school, her husband made an offer of land that was owned by his Wallkill Manufacturing Company in September 1919. A vote of district residents was held at the firehouse on Bridge Street, and it was decided that the parcel would not fit the needs of the district. The parcel rescinded would be replaced by an offer of land by Marion, which was defeated, and so she offered an alternative site on Bona Ventura Avenue free of charge. The proposition was held to a vote on January 7, 1920, and the site was accepted. The Union Free School District No. 5 would eventually be changed to the John G. Borden High School of Wallkill at the urging of Dr. Rorer and Mrs. Deyo.

During her life, Marion remembered what it was like to be a lonely child and thus had a special affinity for children. One individual recollected that she frequently beckoned her personal driver to stop when she saw a child in need. Marion would not leave until that child's needs were met, frequently with a generous contribution. There is no better example of her generosity than the Girl Scouts.

Shawangunk resident Al Smiley writes that Marion believed so strongly in the Girl Scouts of America (GSA) that she gave them the east end of the farm for their use. This section of the farm became a camp that would be christened Camp Wendy in 1923, according to the GSA archives, and is still used today by the Girl Scouts of America. Marion later became the Ulster County chairperson for the Girl Scouts of America. Camp Wendy, "whose name is from the book *Peter Pan* and whose labeled sites are thematically found, i.e.: Greenwood, Lost Boys, Tinkerbelle, etc., is 53.6 acres." The GSA was not the only local organization that Borden helped; she also gave money to the Wallkill Dutch Reformed Church for the addition of an all-purpose room. This all-purpose room later served as a gymnasium for students who attended the Wallkill High School until a proper one could be built at the school. Like her mother, Marion was also a believer in public lending libraries, and she was instrumental in creating the Wallkill Public Library.

Tragedy struck Marion's life in 1927 with the death of her beloved mother. Ellen would be buried next to her husband on Home Farm. Not even two years later, on September 17, 1929, Mr. Halliday was killed at his hat shop in the village. Since few witnesses were present when the accident occurred, no one really knows what happened other than some local residents who remembered hearing that Mr. Halliday was late for supper that evening, which was unlike him. It was determined that he "either fell on or grabbed a high voltage wire and was electrocuted." After a funeral in the Borden mansion, he was buried in Dutchess County in Wappingers Falls. Turning tragedy into a reason to make people's lives better, George Halliday, the town supervisor at the time of his death, had taken out a $25,000 life insurance policy, listing the library as the beneficiary. He also left $5,000 in additional monies from his estate to be given to the library.

The following year was a new decade and one of renewed hope. It was the decade that would see the emergence of Elsie the Cow as the official mascot for the Borden Company. If the last Borden of Wallkill was sick or frail, the newspapers, probably out of respect, were silent. They still reported on Marion's good deeds and even on the several cars she owned, which included a Ford. A little more than a year after her husband died, Marion Borden Halliday, described as elderly by at least one newspaper, passed away in New York City in November 1930 at the same age as her father—forty-seven. The newspapers were silent about the cause of death, but the outpouring of emotion was beyond anyone's wildest imagination.

The newspapers of the day reported that Marion's funeral was a simple one. So many mourners came to the modest Wallkill Reformed Church,

The graves of John G. Borden; his wife, Ellen; and daughter, Marion, on the grounds of the mansion. Today, the mansion and surrounding property are owned by the School of Practical Philosophy. *Authors' collection.*

one of the few properties not owned by the Borden family, that they could barely fit. The funeral was officiated by the Reverend Dr. Leggett, who told the assembled crowd that it would be impossible to eulogize such a great woman in such a short period of time—so he did not attempt to reflect on such a distinguished life. He looked over the crowd of more than four hundred people who packed the church that November afternoon to bid farewell to the last Borden to live in Wallkill. He spoke of her "cheery smile and her kindly deeds," known to everyone she met. In an effort to pay homage to their fallen benefactor, family members did not carry the coffin from the church; instead, loyal employees served as the pallbearers. These loyal employees were remembered in Marion's last will and testament. Her remains were later cremated and buried on the land she loved so much, next to her father and mother.

Marion Borden's death marked a turning point in the history of the hamlet of Wallkill. Her philanthropic hand gave in death as much as it had in life. Marion, like her late husband, left $25,000 to the library. In addition to this large sum of money, she also left a trust fund of $5,000 for permanent maintenance. As far as Home Farm, she created quite a stir

The Reformed Church, where Marion Borden was a congregant. The all-purpose room pictured here, donated by Marion Borden, served as the Wallkill High School's first gymnasium. Marion's packed funeral was held at this church in 1930. The high school is visible in the center of the postcard. *Authors' collection.*

amongst her surviving siblings by leaving it to the Masons, with "the bulk of the Borden estate going to charity and civic causes, including $100,000 to the Girl Scouts of America, $20,000 to the Salvation Army, $50,000 to the Orthopedic Hospital of New York. She also gave $25,000 each to Kingston Hospital as well as St. Luke's Hospital." Additional monies were also given to the YWCAs of both Kingston and Newburgh. Marion Borden also left a sizeable amount, as high as $25,000 apiece, to those who were loyal to her in life, including friends and lifelong employees of the Borden Company. Employees were also given a year's salary plus extra money for each year of loyal service. One individual was left one hundred shares of company stock.

Perhaps Marion's longest-lasting contribution was a piece of land deeded for the construction of the Wallkill High School, as she left monies for the construction of the school auditorium and a swimming pool. Thirteen years later, the community still mourned its benefactor. In a gesture of remembrance in 1943, the John G. Borden High School christened its new auditorium the Marion Borden Auditorium.

When traveling the streets of the hamlet of Wallkill, we are often reminded of the legacy of the Borden family. Their hand in the shaping of the hamlet

is still seen and felt. In fact, John G. Borden's "grid" for the growth of Wallkill is still followed, for the most part, today. Only recently, according to local newspapers, has Wallkill started to outgrow the original town square devised by Borden. Relatively recently, in an effort to recognize the impact of the Borden family on the town, the Shawangunk and Gardiner Historical Society developed a Borden Day event to be held on an annual basis.

Chapter 8

The John G. Borden High School

In the presence of the Union Free School District No. 5, Shawangunk No. 5 and on behalf of the faculty and student body, I accept the use of the John G. Borden High School building and give assurance that it is our intention that the instruction shall be of such a lofty and patriotic standard, which comes from the study of the best characters found in the annuls of American history and literature, that our youth shall mature in good citizens and true patriots, and if we do this, the John G. Borden High School which we dedicate today shall have served this community well, and as part of the school system of the state shall have contributed its quota toward a better America and future generations can say as we say today, "The Star-Spangled Banner, oh long may it wave. Oe'r the land of the free and the home of the brave."—John U. Gillette, Ulster County District Superintendent of Schools, in a 1922 dedicatory address at the opening of the John G. Borden High School.

There are numerous activities connected with our school. Each year, the senior class puts on a play. The grade school children put on an operetta every spring. Numerous speaking and spelling contests have been held in the last few years. The school aids in many other ways in fitting children of the community to be good citizens, including a part in the Memorial Day Parade.—John G. Borden High School student Howard Terwilliger in his 1938 Salutatorian Address

Life is still simple here for the residents of the hamlet of Wallkill, and except for fewer farms, alumni returning to the John G. Borden School would still see cars driving past the school on Route 208, meandering by the stately homes on Bona Ventura. The local firehouse is still the center of the community, and even Wallkill Avenue has changed little except for the post office, which has changed location a few times over the years. There is a sense of history about the John G. Borden School, which sits across from the same hay fields it did when it was carved from the vast Borden estate in 1922. It has stood silently through many of this country's best and worst moments—wars, assassinations, the moon landing, V-E Day, 9/11. Its weathered brick façade tells the story of this proud beacon that guards the southeastern entrance of the hamlet of Wallkill with the calming effect of a watchful parent.

Alumni returning would still witness students showing up in the morning like bees returning to a hive, gradually becoming more and more numerous as the early morning wanes—some arriving by bus or cars and still others walking. Teachers still greet the children entering the school as parents welcoming their children home after being away. It is in some respects a scene out of the Norman Rockwell paintings that still stand in the hallway of the school. Perhaps one thing returning alumni would recognize about the John G. Borden School is that it is no longer a high school or even a junior high school but a middle school. It would be also obvious that the land it is situated on has become more of an island as the school has been expanded over the years to accommodate a growing population of students as was the reason that this school itself came into being.

The Wallkill High School started out on Bridge Street, just off of Main Street in the hamlet of Wallkill. In 1919, an advisory board was created to choose a site for a new school building with ample acreage for expansion. The new building would need to have sports fields and room for additions to meet the changing needs of both the student population and the community. The current site was chosen not only because of its central location but also because the Borden family of Borden Condensed Milk fame gifted nearly four acres of land to the Wallkill District in order to build the school.

Some residents did not agree with the location of the new school, believing that the four-acre plot would not allow for future expansion. The price, however, could not be argued with, and so the land gifted by Marion Borden Halliday was eventually accepted for use in building a new district high school.

Construction, overseen by George E. Lowe of Kingston, started in 1920 and was completed in 1921. Students attended school in the Wallkill Union Free

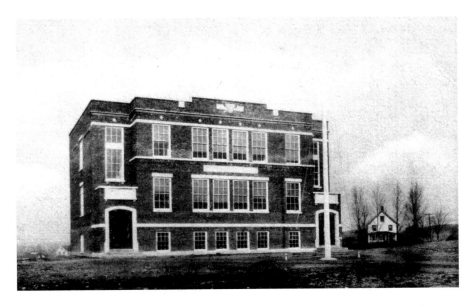

One of the earliest pictures of the John G. Borden High School of Wallkill, from a circa 1925 postcard. (Notice the house to the right, which still stands today.) The card was sent from teacher Ethel Cashman to a friend and reads, "Dear Mildred, I thought you might like to see where I spend most of my time. I like the place very much, I haven't made up my mind about the rest. It's hard after chemistry! Love, Ethel." *Authors' collection.*

School building until September 1922, when the new high school officially opened. The new building was christened the John G. Borden High School, named for the individual who had founded Home Farm, the Borden Estate across from the school. The school's benefactor in 1921 was Marion Borden Halliday, the granddaughter of Gail Borden, inventor of condensed milk. The John G. Borden High School would house students from kindergarten through twelfth grade, with a total of 183 students enrolled on the first day of school—50 of whom were high school students.

The principal of the new John G. Borden High School was Warren G. Grey of Watervliet. There was a total of seven teachers (including Grey), and that year in June there was a graduating class of eight students. The first teachers in the John G. Borden High School were as follows: Florence M. Smith of Albany (French and English), Sylvia Agnes Barrett of Saratoga Springs (Latin and History), Jane R. Van Wyck of Wallkill (seventh and eighth grades), Margaret B. Roosa of Wallkill (fifth and sixth grades), Janet P. Brown of Wallkill (third and fourth grade) and Margaret J. Hinckley of Binghamton (first and second grades). Members of the Board of Education

included M.J. DeWitt, Marion Borden Halliday, C.G. Crossely, J.H. Lyons, J. Addison Crowell, Thomas H. Titus and Mary A. Titus.

To open the school year on September 5, 1922, the students of the Wallkill Union Free High School gathered at their old school at 2:30 p.m. and "marched in a unified body to the new building; they were led by Marcinkowski's Orchestra." They gathered on the third floor of the new high school to participate in the official dedication of the John G. Borden School. The celebration included performances by the school band and addresses by New York State Historian Dr. James Sullivan, President Martin J. DeWitt and District Superintendent of Schools John U. Gillette. Teacher Margaret Roosa, who had been in the first graduating class at the Wallkill Union Free High School, presented a brief history of education in the hamlet of Wallkill, while Marion Borden Halliday, chair of the committee on arrangements for the ceremony, helped preside over a parade of students. It was recognized by at least one speaker that the current school could not have come into being if not for John G. Borden, who decided on bringing his business headquarters and family home to Wallkill, New York. It was his vision of the town that allowed for the piece of land that the school would later call its home. Superintendent of Schools Gillette said in part:

> *When a small boy looking over an atlas of Putnam County, my native county, I was impressed with a picture of the factory of the Borden Condensed Milk Co., incorporated January 28, 1864, by Gail Borden Jr. and two other gentleman. On the death of Mr. Borden, the management and development of his large interests devolved upon his son, John Gail Borden. Pelletreau's History of Putnam County reads, "As a public spirited citizen he left behind him, when he removed to Ulster County in 1881, a place not easily filled. His large benefactions have helped to complete the present schoolhouse, the town hall and Baptist Church, and his aid was given to every good work and brought comfort to many a needy household." It is assumed that a continuation of this benevolent spirit in Ulster County has led those in authority to designate this school building the John G. Borden High School.*

Following the addresses by Gillette and Sullivan, the attendees were invited to inspect the new building. Classes began the following day.

The Wallkill District Board of Trustees voted in May 1922 to sell the former Union Free High School building and the property "for the best price obtainable." In September of that year, the property, school and outbuildings were sold to

George Halliday for $2,000. The old high school was torn down shortly thereafter, with part of the structure being moved to a nearby property.

The John G. Borden High School eventually had a recreation room and bathrooms with showers in the basement. A student coming up from the basement would find three classrooms, a principal's office and a library. The second floor had five high school rooms that were broken up into an eighth-grade room, a laboratory, a Latin room and assembly and English rooms. Marion Borden Halliday donated $1,000 to grade the grounds of the new school.

When Ms. Borden Halliday

● JOHN G. BORDEN ●
HIGH SCHOOL
ERECTED A.D. 1921
BOARD OF EDUCATION
MARTIN J. DEWITT PRES.
MARY A. TITUS SECT'Y.
THOMAS H. TITUS TREAS.
MARION BORDEN HALLIDAY
CLARENCE V. CROSSLEY
JAMES H. LYONS
J. ADDISON CROWELL
ARCHITECT
GEORGE E. LOWE
KINGSTON N. Y.
GENERAL CONTRACTOR
CLARENCE VANAKEN
KINGSTON N. Y.
PLUMBING AND HEATING
H. E. WILLIAMS CO.
WALDEN N. Y.
ELECTRIC WIRING
HEWITT AND WARDEN
NEWBURGH N. Y.

The marble plaque located just inside the John G. Borden Middle School (the former high school). *Authors' collection.*

died, the district was pleased to learn that the last of the Wallkill Bordens had willed approximately $50,000 to the school for the purposes of enlarging the building. She also directed the district to, at some point, construct a swimming pool, but when the first addition was completed in 1935, it consisted of a gymnasium, an office and five additional classrooms, including a science lab. The cornerstone to the new addition was laid on May 1935, with Ulster County District Superintendent Ralph H. Johnson and Mrs. Samuel Sharp, president of the Borden School Board of Education, officially dedicating what they termed the "Marion Borden Addition."

The John G. Borden High School was a point of pride for members of the community, who often held fundraisers to support students at the school. The addition of a "moving picture machine with a sound system for the auditorium and class room work" in 1938 was highly praised by local reporters. A second addition, completed in 1943, included "eleven regular classrooms [and] special rooms for industrial arts, agriculture, home economics, science,

music, kindergarten, a library, cafeteria and an auditorium," which was named in honor of Marion Borden. This addition, part of a $285,000 bond issue that included a four-room elementary building in Plattekill, caused "the residents of Galeville, Hoagberg, Bruynswick, Rutsonville, New Hurley and Plains Road [to authorize] the closing of those schools so that their children might be sent to the Wallkill school."

The 1937–38 school year was a turning point for the John G. Borden High School, for it was the last year that the school would remain part of its own district. Centralization would come the following fall, and with it the closure of many of the neighborhood schools. In his 1938 commencement address, salutatorian Howard Terwilliger remarked on the district's past while recognizing the changes about to take place in just a few short months:

Before closing, I should like to state some facts to show how our school has grown. From a one-room school, we have grown to a school of ten rooms, a laboratory and a gymnasium. When this school building was first used in 1922, 183 pupils were enrolled. Today, the enrollment is 296. Of this enrollment, 134 are in high school, as compared with 50 in 1922. In addition to growing in size, our school has grown in academic standing. The average of the Regents marks of everyone in this class is higher than

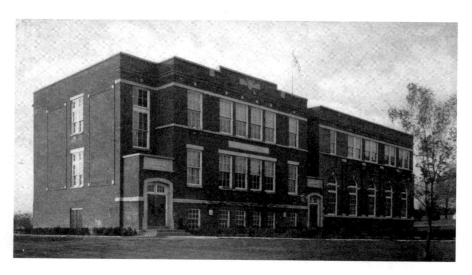

The John G. Borden High School with a new addition that includes the gymnasium made possible with money left by Marion Borden. It was her hope for a swimming pool for the students. *Authors' collection.*

84

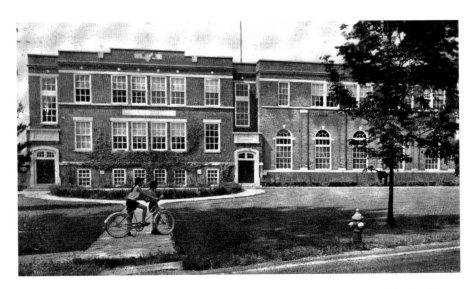

The high school in another era. Today, where the children stand serves as parking lot for faculty. The two entrances are for boys and girls to enter separately. *Courtesy of Historic Huguenot Street Archives, Kenneth E. Hasbrouck Collection, 1915–1994.*

that of some of the valedictorians in previous years. Every member of the class of 1938, with the exception of one whose residence in another state made her ineligible, has earned a State Diploma. Every senior has passed every Regents subject. It may be surprising to know how many graduates of this school go on for further education. Out of 162 graduates up to and including 1937, 95 have gone on to colleges, universities, business schools or similar places where vocational education may be acquired.

We have been very fortunate in having men and women in our community who had the foresight to realize the coming need for good educational facilities. It was they who started the work that has led to our present system. We must not stop now, but forge ahead, confident that when we are building a fine school, we are building one of the community's most worthwhile institutions.

Part III

The Wallkill Central
School District

Chapter 9

Centralization

Notice is hereby given that under the provision of Article 6-B of the Education Law, Central School District has been laid out by the Commissioner of Education comprising Union Free School District No. 5 of the Towns of Shawangunk, Ulster County and Montgomery, Orange County, and Common School District No. 6 of the Town of Shawangunk, Ulster County, Common School District Nos. 8 and 9 of the Town of Shawangunk and Gardiner, Ulster County, Common School District No. 2 of the Towns of Shawangunk and Plattekill, Ulster County and Newburgh, Orange County, Common School Districts Nos. 1,2,4, and 8 of the Town of Plattekill, Ulster County, Common School District No. 7 of the Towns of Plattekill, Ulster County and Newburgh, Orange County, Common School District No. 10 of the Towns of Plattekill and Marlboro, Ulster County, Common School District No. 7 of the town of Gardiner, Ulster County, Common School District No. 3 of the Towns of Gardiner and Shawangunk, Ulster County, Common School Districts No. 2 and 7 of the Town of Newburgh, Orange County and Common School District No. 6 of the Towns of Newburgh, Orange County and Plattekill, Ulster County, all of said Union Free and Common School Districts being in the State of New York, and that a meeting will be held of the inhabitants of such Central District, qualified to vote at such District meeting, at the John G. Borden High School, at Wallkill, being District No. 5 of the Towns of Shawangunk, Ulster County on the 31st day of October, 1938, at 2:30 p.m. for the purpose of voting on the following question, polls to remain

open for voting until 8:00 PM o'clock. "Shall a Central School District Be Organized as Laid Out By the Commissioner of Education, And A Central School Be Established Therein Under the Provisions of Article 6B of the Education Law." October 26, 1938 Notice of Election

At a meeting held Monday evening at Wallkill, voters of 17 school districts in the towns of Gardiner, Shawangunk, Plattekill and Newburgh voted 576 to 207 for centralization. With a total of 783 votes cast on the proposition of whether a Central School District should be formed, the proposition was carried nearly 3 to 1.—Kingston Daily Freeman, November 1, 1938

Talks of centralizing the common school districts throughout New York State began as early as 1917 with the New York State Legislature's proposed "Township System for Schools." The Township System called for consolidating resources such as transportation and creating centralized high schools in the larger towns. One of the most outspoken opponents of the proposed system in Ulster County was teacher Flora Malcolm, who taught for many years in the one-room Ardonia, New Hurley and Gerow Schools in the towns of Plattekill and Gardiner. Malcolm wrote an impassioned plea to New York State asking lawmakers to consider the harmful effect centralization would have on students attending the rural neighborhood schools:

Transportation of children…would mean that children must be transported in conveyances to some village school, a thing that every right-minded parent knows would be even dangerous to the welfare of the child. The children who now walk to school through the snow are not the ones who complain most of the cold when they reach the school. It is those who ride that suffer, and often cry with cold hands and feet. What would it be when the little ones came to ride five or six miles on a cold day? It would be very hard on the poor, as they would be obliged to buy extra clothing, which children would not need if they walked to school. It is not such a hardship for teachers and children to walk to school as some people who coddle themselves up in heated houses think it is.

Regarding the creation of a high school in the larger towns where students would be separated by grade, Malcolm was just as adamant:

It is very doubtful if the building of a high school in every town will really educate any more young people than are being now educated. The high school is what every town might do well to have, but leave the younger children in the rural school. Let them be in a room where there are all grades, and when they reach the high school, they will stand as well or better than those children who passed out of one grade into the next and did not have the opportunity to hear the other grades recite as they do now in the rural school. Those children who are determined to leave school as soon as the law will allow it will still do so, but the boy or girl who really wants an education will get it under the present system and will make all the better man or woman for having had to work for it.

While the Township System fell through, the state continued to search for ways to consolidate services in order to relieve taxes imposed on residents, especially in rural areas, where the enrollment in the district common schools had declined considerably. The New York State Board of Regents determined that the smaller neighborhood districts should consolidate services and decide upon the location of a central school that would provide services for high school students. By 1925, New York State was offering financial incentives to common school districts that combined services. In southeastern Ulster County, meetings were held throughout the 1930s to review the impact of centralizing the neighborhood schools in the area into a common district. A special Board of Education meeting was held on July 27, 1938, to discuss the potential impact on local districts if they did not centralize. County Superintendent Ralph Johnson explained that if the local districts did not centralize by 1940, New York State would determine the boundaries of the districts and make the decision regarding where the central school would be located. Trustees from twenty neighborhood districts (including Crawford and Dwaarkill in the town of Shawangunk) met on July 29 in the Shawangunk Reformed Church Hall to discuss the various options.

The Wallkill Central School District No. 1 was formed in October 1938 by a majority vote of residents (576 for and 207 against the proposition). The newly formed district included the John G. Borden High School and its academic department, or high school courses, and sixteen of the common school districts located fully or jointly in the towns of Gardiner, Plattekill, Marlborough and Shawangunk in Ulster County and Newburgh and Montgomery in Orange County. Consolidation brought together the two-room Modena and Leptondale Districts; the joint New Hurley District and the one-room districts of Bruynswick; Rutsonville and Benton's Corners

in Gardiner; Hoagberg, Galeville and Plains Road in Shawangunk; Forest Road and Savilton in the town of Newburgh; and Unionville, Gerow, Plattekill Valley, Sylva and Prospect Hill in the town of Plattekill into a system centered in the hamlet of Wallkill. Early district handbooks referred to the John G. Borden High School—which by now contained all twelve grades and was by far the largest school in the new district—as "a nucleus for the new district."

Enrollment records during the first year of consolidation for students in grades one through twelve was somewhere between 780 and 820 students, with approximately 200 of those students enrolled in grades nine through twelve. The student population decreased slightly in the following years as work on the Delaware Aqueduct was completed and the children of aqueduct workers moved away from the district.

As a result of centralization, most of the neighborhood schools closed by the mid-1940s. Eighth- and, eventually, seventh-grade students in the remaining schools were bussed to the John G. Borden High School. Younger students in the remaining neighborhood schools received more district services, including a physical education teacher from Wallkill who would travel to the buildings once a week, a traveling music teacher and routine visits by a district physician, nurse and dental hygienist. The new district was able to offer a broader array of high school courses. Most were taught on site, while others were held in various locations in the hamlet, such as agriculture courses that were held in Ronk's Garage.

The new district featured a Board of Education, consisting of five members elected by residents of the district during a special vote in July. One member was elected each year. The board met on the third Tuesday of each month. In addition to the board, the district had a clerk, treasurer and supervising principal who was responsible for hiring and supervising teachers and for the district's curriculum. A county-level district superintendent of schools helped with the hiring process. With centralization, the administrative structure in the district also changed. The district was run by a supervising principal, Mr. Dexter G. Tilroe; a vice-principal, Mr. Robert J. Robinson; and an assistant principal for the elementary grades, Miss K. Florence Morrissey. When Tilroe was called into military service midway through the 1941–42 school year, Robinson became acting principal, and Morrissey, who had been a teacher at the Modena School for ten years, became the supervisor for the elementary and rural schools in the new district. Part of her duties included traveling to the remaining rural schools and administering Regents Exams and

other assessments to students. (She did this in addition to teaching social studies for grades seven through nine.)

Teachers were required to hold a four-year college degree and valid teaching license. An additional thirty hours of coursework would entitle teachers to a raise in salary, as indicated by column two of the 1950–51 salary schedule below:

Salary Step or Year of Service	Year 1	Year 2
1	$2,500	$2,700
2	$2,600	$2,800
3	$2,700	$2,900
4	$2,950	$3,150
5	$3,100	$3,300
6	$3,250	$3,450
7	$3,400	$3,600
8	$3,550	$3,750
9	$3,700	$3,900
10	$3,850	$4,050
11	$4,000	$4,200
12	$4,000	$4,200
13	$4,300	$4,500
14	$4,300	$4,500
15	$4,300	$4,500
16	$4,600	$4,800

(Substitute teachers were paid $12.50 a day.) Teachers were also required to pass a physical exam—one that included a chest X-ray—as a condition of probationary appointment or tenure. Students older than fourteen who had a valid employment certificate could earn money for doing jobs around the school. For example, in the early 1950s, a student willing to work in the cafeteria during his or her lunch period could earn $0.40 a day.

The school day at the John G. Borden High School began at 8:35 in the morning, with dismissal at 3:49. Because many students did not have a study-hall period during the eight-period day, teachers were required to devote at least ten to fifteen minutes of every fifty-minute class to "supervised study."

By 1945, open houses for all schools in the district were being held in the high school. Grades two through twelve were all represented on a single night in the building. (Kindergarten and first-grade classes held their open houses in the four classrooms of the Main Street Annex school, today's district office.) Local newspapers reported "large throngs" of more than six hundred parents and community members who would attend the open houses, where they would be treated to hours of demonstrations and exhibits by teachers and students alike. A notable exhibit in 1946 featured student agricultural displays housed inside the high school, including an egg-candling demonstration and stalls of chickens and calves. Prior to the district open house, the public was invited to make "evening inspections" at the Modena, Plattekill, Benton's Corners, Forest Road, Leptondale and Plains Road schools.

Upon centralization, the Wallkill Central School District of the towns of Shawangunk, Plattekill, Gardiner and Marlborough in Ulster County and Newburgh and Montgomery in Orange County covered more than one hundred square miles, making it one of the largest school districts in New York State. (The towns of Marlborough and Montgomery would later be dropped from the district's name.) Thanks to the generosity of Marion Borden Halliday, the district boasted the only school in the region to have a separate auditorium and gymnasium. Despite the Borden contributions, however, one final result of consolidation was the renaming of the John G. Borden High School in 1945. Members of the Board of Education, feeling that the Borden name caused confusion, resolved that the high school should be reflective of the status of the new district. In November of that year, by act of the New York State Board of Regents, the name of the John G. Borden High School was officially changed to the Wallkill Central School.

Chapter 10

The 1940s to the Present

My education started at the Plattekill Elementary School in 1957. When I was in first and second grade, the first renovations of the school began. I had to attend the little schoolhouse on Quaker St. I loved school…my teachers would let me put pictures up with Sticky Tac. I decided then that I wanted to be a teacher. I graduated in 1970. My high school years formed so much of the person I am today, thanks to a very special teacher, Mrs. Hedi Herman. In 1985, I started my career in Plattekill Elementary School. In 2014, I will retire after twenty-nine years as a Certified Teaching Assistant. I am so grateful to give back to the district that has given so much to me.—Rosemary Denardo Zappala, Wallkill High School Class of 1970

I would like to mention that there were some EXCELLENT teachers that have influenced my life to this day, [such as] Mrs. Ilona Herder, who was the business teacher and trained all students to be excellent secretaries. She even created a job placement program where personnel administrators from area businesses would come in and interview the top three graduates around March for job openings in their companies (IBM, Central Hudson, SUNY New Paltz, etc.) I was interviewed in March and offered a job at all three and accepted the job at SUNY New Paltz as a secretary. They held the job until I graduated on June 25, 1967. What a concept to place students in jobs before they graduated!—Linda Napoleone Garcia, Wallkill High School Class of 1967

Following centralization, the Wallkill Central School District continued to undergo a series of transitions for many years. A great deal of coordination was required in creating district activities that would involve students and teachers from every school. A district-wide PTA organized activities that would bring students together and ensure that students in the rural schools had the same opportunities as those attending school in Wallkill. A district-wide spelling contest was held in the spring of 1940, and the results, published in the May 23, 1940 edition of the *Kingston Daily Freeman*, highlight how widespread the new district was:

> *The program at the P.T.A. meeting this week was two spelling bees. One from the fourth, fifth and sixth grades, which was won by Margaret Fox of the Forest Road school. Miss Betty Donahue pronounced for them, and in the seventh and eighth grade contest, the honor went to Lea Spagnoli of the Gerow district. Leo Spagnoli will also represent the Wallkill Central School at Kingston in the county spelling contest. Mrs. Richard Meredith pronounced the words for this group. Other students in the fourth, fifth and sixth grades in the spelling contest were Mila Moore of Savilton, Barbara DuBois of Modena, Gilmore Harris of Prospect Hill, Lucy Campbell of Unionville, Ernest Dibble of Plattekill, Dorothy Scott of Sylva, Peggy Ann Smith of Hoagburg, Thelma Conner of Benton's Corners, Norma Waltke of Rutsonville, Jeanne Carpenter of Bruynswick, Angelo Ruggiero of Gerow, Rita Mulqueen of Galeville, Doris Terwilliger of Plains Road, Alice Krause of Wallkill, Norman Eckert of New Hurley and Joan Delapp of Leptondale.*
>
> *In the seventh and eighth grades were Bernice Every of Modena, Mildred McEntee of Benton's Corners, Jean Lampart of Rutsonville, Jean Steffe of Savilton, Kathleen Malloy of Wallkill, Robert Miller of Forest Road, Theresa Bonczek of Sylva, Mary Gusofsky of Unionville, Helen Schrio of New Hurley, Alice Birdsall of Prospect Hill, Virginia Van Wart of Bruynswick and Theresa Rice of Shawangunk.*

Within two years of its formation, the district saw the need for construction of a new elementary school. The Wallkill Central School was overcrowded to the point that classes were being held in the boiler rooms and locker rooms. The remainder of the bequest from Marion Borden Halliday, as well a public vote on a bond, allowed the district to enlarge the Wallkill Central School by constructing an addition that was larger than the original building. Gordon Marvel of Newburgh was the architect, and Dominic La Cascio of

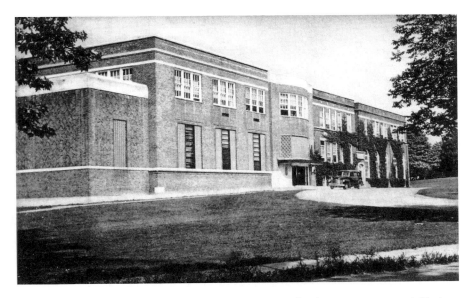

The high school post–1943, when the Marion Borden Auditorium was constructed. Notice the new atrium that is the main entrance. *Authors' collection.*

White Plains was the contractor. The addition included a new auditorium, named in honor of Marion Borden Halliday; a three-story "L-shaped" wing with a cafeteria; a shop; an agriculture room; a music room; a kindergarten room; a library; and additional classrooms. The kindergarten room opened into a terrace, creating outdoor space for the students.

The bond sale also helped finance the construction of a four-room grade school at Plattekill. The two projects were completed at a cost of approximately $285,000. Construction on the new building began in 1941, and on December 5, 1941, students from nearby one-room schools in the centralized district helped to lay the cornerstone for the new Plattekill Elementary School. Student representatives were chosen from each of the six closest neighborhood schools to place a commemorative object in the cornerstone. Included with the objects were class lists and the names of the teachers of the six schools: Catherine Bell Thompson (Gerow School), Mrs. Harold Jenson (Plattekill Valley School), Dorothy White (Prospect Hill School), Mary Fitzpatrick McCartney (Savilton School), Kenneth Hasbrouck (Sylva School) and Wilma Sigmund Klein (Unionville School).

Construction was completed by mid-1942. This new brick building, known as the Plattekill Elementary School or the Plattekill Branch School, served students from the Plattekill Valley, Sylva, Prospect Hill, Unionville

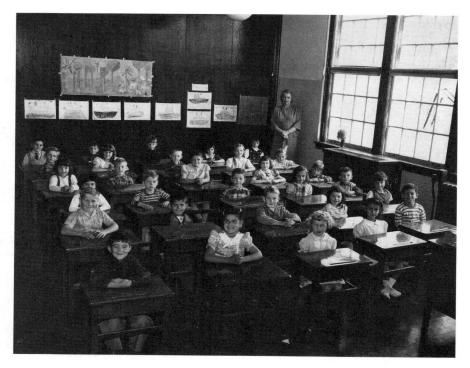

A first-grade class at the Plattekill Elementary School, circa 1949. *Authors' collection.*

and Gerow Schools in the town of Plattekill and the Savilton School in the town of Newburgh, all of which closed so that students could attend school in the new building. The Plattekill Elementary School had the capacity to house 160 students from seven of the surrounding one-room schoolhouses. It contained a sliding partition between the two rear rooms that provided assembly space when removed. The new building also contained a faculty room and an office. Instead of walking to the closest one-room school, students were bussed to Plattekill. The Plattekill Elementary School initially contained four rooms and served students in grades one through eight. During its first year, the school had an average enrollment of 114 students: 31 students in grades one through two, 33 in grades three through four, 26 in grades five through six and 24 in grades seven through eight. The following year, the seventh- and eighth-grade students began attending school in the John. G. Borden School. In the spring of 1943, Central Hudson donated an electric stove to the district so that Plattekill students could have a hot lunch program.

Until the addition to the Wallkill Central School was completed in 1943, the elementary grades in Wallkill remained on a half-day schedule, and some classes were held in the rooms above Edsall's drugstore on Wallkill Avenue and in the community hall of the Wallkill Reformed Church. In May 1943, the dedication of the updated Wallkill Central School District building was held. During the 1943–44 school year, kindergarten started for the first time, with a Miss Gulek serving as the district's first kindergarten teacher. A kindergarten program was added to the Leptondale School in 1947. With the expansion of the Wallkill Central School building, taxpayers voted to close the one-room schools at Galeville, Hogaburg, Bruynswick, Rutsonville, New Hurley and Plains Road.

World War II brought its own set of challenges to the new district, as several faculty members, including the supervising principal, joined the war effort, and five former Wallkill students—Corporal Earl Halstead, Sergeant William Harcher, Gunners Mate Arnold G. Sheeley, First Lieutenant Robert Lown, Seaman First Class Herbert Earl and Private Joseph M. Garcia—were killed in action. During the World War II years, a faculty member served as an air-raid warden and was responsible for teaching older male students to be fire wardens. Fire wardens were trained to put out incendiary bombs and in what do in the case of an air raid. At the neighborhood schools, supplies of canned fruits and dried beans were supplied to students by the government, and teachers would cook thick soups on the pot-bellied stoves for the students' lunches. Students were encouraged to buy war stamps, which in turn could be traded for war bonds. Community drives were held to help students reach certain goals in buying the bonds. The district library, housed at the Wallkill Central School, was charged with starting a collection of books and pamphlets on war and civil defense, as well as creating patriotic displays.

During the 1950s, several Wallkill teachers served as members of the School Defense Council, a group put in place "in case of enemy attack on the eastern Coast of the U.S." Teachers on the council were instructed in first-aid procedures, taught safety drills and served on town safety organizations. All teachers in the district were provided instruction on such topics as "The Atomic Bomb and Protection From It" and "Guarding Children Against Fear."

From its beginning, the Wallkill Central School District promoted various health initiatives that taught students about diseases and encouraged them to raise money for those in need. The initiatives began in the 1940s with education on tuberculosis and polio and covered a number of topics over

the years—everything from promoting dental health and fighting acne in the 1960s and 1970s to smoking cessation in the 1980s and AIDS awareness in the 1990s to the present-day Relay for Life fundraisers for cancer research. Food and clothing drives have been ongoing traditions that continue to the present. In the 1950s, the district shared a dental hygienist with New Paltz Central School. The hygienist inspected students' teeth, gave sodium fluoride treatments to students in some grades, instructed elementary students in dental education and cleaned teeth.

By the 1950s, elementary students in Wallkill were schooled in several different buildings, including the **Main Street Annex** in the hamlet of Wallkill (the current district office building). The two-story Annex building, purchased by the district in 1950, had a rich history. The late *Walden Citizen Herald* columnist Frank Mentz wrote that the building was constructed around 1870 and used as a hardware store and tin shop. The building was later purchased by farmer Willet Roos, under whose ownership it became

Once the hotel of Willet Roos and later the Main Street Annex school, this building now serves as the district office for the Wallkill Central School District. *Courtesy of Historic Huguenot Street Archives, Kenneth E. Hasbrouck Collection, 1915–1994.*

one of the most well-known hotels in Ulster County. Roos was known as an excellent cook and kept pigs and chickens on the property. In 1912, the hotel was purchased by the Wallkill National Bank; the Wallkill Central School District purchased the building when the bank moved to Wallkill Avenue. The Annex served students in grades one through six in several classrooms. Former student Dennis O'Mara recalls that students whose classrooms were on the second floor would have to climb a set of fire-escape-like stairs on the outside of the building in order to reach their classroom. Interior stairs were added much later.

The Annex was a temporary solution to the overcrowding problem and quickly became too small to accommodate the growing number of students in the Wallkill area. In April 1951, the district was able to purchase twenty-six acres just off of Viola Avenue in the hamlet of Wallkill. The property was originally part of the DuBois Farm, which stretched to the Wallkill River. The following September, taxpayers voted to build a new elementary building. Construction was completed during the 1954–55 school year, and

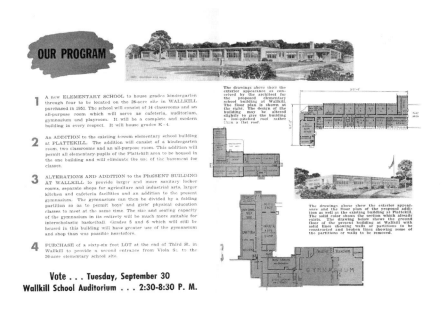

A 1950s budget brochure showing potential plans for the Wallkill Central School (which housed fifth- through twelfth-grade students at the time), the new Wallkill Elementary School and an addition to the Plattekill Elementary School. *Courtesy of Wallkill Central School District Historical Archives.*

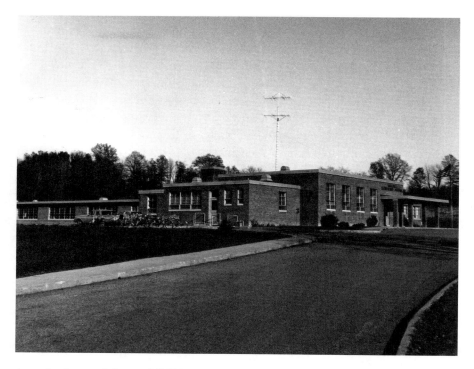

An early picture of the new Wallkill Elementary School on Viola Avenue. The entrance to the school was renamed "Peter Riggins Way" in 2012 to honor former teacher and principal Peter Riggins, who passed away that year. *Courtesy of Historic Huguenot Street Archives, Kenneth E. Hasbrouck Collection, 1915–1994.*

on April 19, 1955, the **Wallkill Elementary School** opened to students in grades K–4. To celebrate the opening, students in the Annex packed up their belongings into paper bags and walked with their teachers over to their new classrooms at the Wallkill Elementary School for their first day of classes. An open house was held in May 1955 to allow the public a chance to tour the new building. More than five hundred people attended. The new building contained fourteen classrooms, including three kindergarten rooms, an all-purpose room, a cafeteria, health offices, a library, administrative offices and a faculty room. Keys to the building were ceremoniously turned over to Board of Education president DuBois Grimm by the general contractors for the project.

Meanwhile, in the town of Plattekill, the Plattekill Elementary School building was becoming too small for a burgeoning population, and by the 1950–51 school year, kindergarten students began attending the Modena

School, while first-grade students were sent to the small Leptondale School on Quaker Street in the town of Newburgh.

During the 1954–55 school year, a substantial addition was completed at Plattekill that included a kindergarten classroom, two primary classrooms, a kitchen, a health office, an all-purpose room/ gymnasium and storage space. The addition cost approximately $200,000 to complete and was designed by architect Harry Halverson of Kingston.

A Plattekill Elementary School program. Mrs. Margaret Fosler was the principal of the Plattekill Elementary School at the time of the addition. Mrs. Fosler retired from the district in 1971, after thirty-one years at Wallkill, thirteen of which she served as principal of the Plattekill Elementary School. *Courtesy of Town of Plattekill Historian's Office.*

Upon completion in February 1955, students who had been attending the Modena and Leptondale Schools due to overcrowding at Plattekill returned to their home school. An open house was held on April 26, 1955, where more than two hundred district residents toured the building, listened to a history of the school and participated in a benediction and dedicatory prayer led by pastors from the Modena Methodist Church and the Our Lady of Fatima Catholic Chapel. In April 1957, the Wallkill Board of Education hired the first business manager and clerk of the district. Clifford E. Caswell, a veteran of World War I who had been educated in Wallkill, was appointed to the position. A description of his job was noted in the December 1957 *Blue and White* student newspaper:

> *His duties are manifold: he has charge of all purchasing, receiving and checking of all goods bought for the school, of cafeteria account, of internal school account, the keeping of records of school transportation, preparing and sending notices of all district meetings which have to be duly advertised, collecting of taxes, serving as secretary of all regular and special meetings of the board, assembling of data for the budget, preparing notices of appointment of new teachers, taking charge of construction fund records and many other duties.*

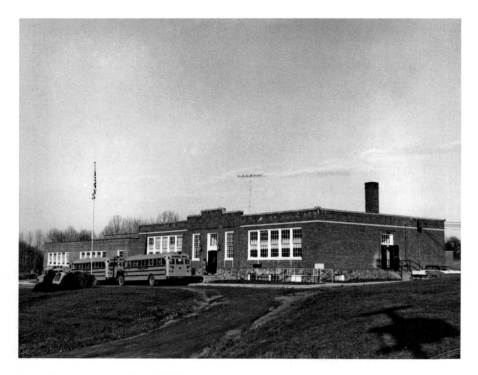

An early image of the Plattekill Elementary School. A war memorial, donated by the "Village of Plattekill," can be seen in front by the flag. The main entrance to the school at that time was in the front of the building facing Route 32. *Courtesy of Historic Huguenot Street Archives, Kenneth E. Hasbrouck Collection, 1915–1994.*

In August of that year, taxpayers voted to purchase a twenty-acre site on Mill Street in the town of Newburgh for the potential construction of a new elementary school to replace the existing Leptondale School. Construction proceeded rapidly, and the Leptondale Elementary School opened in 1959 with nine classrooms, a kindergarten room, an all-purpose room, a kitchen, a health office, an administrative office, a faculty room, a library and storage space. In June of that year, the school was dedicated in a ceremony in which keys to the school were turned over to the Wallkill Central School District administration. The faculty members in the new school timed the ceremony to coincide with National Education Week. Among other activities, an open house was organized the following November to allow the community to tour the new school. Approximately five hundred people attended the dedication ceremony. A description of the ceremony appeared in the November 11, 1959 edition of the *Newburgh News*:

The program included a presentation of colors and salute to the flag by Cub Pack 27 and Scout Troops 27 and 79; and invocation by the Rev. Donald Valenti, pastor of the East Leptondale Bible Chapel; a welcoming talk by Crosby J. Wilkin, president of the Wallkill Central

District Cafeteria Lunch Menu in 1962

Plattekill School:

Monday: spaghetti with meat sauce, buttered carrots, cheese cubes, French bread and butter and pineapple ring

Tuesday: oven roast beef and gravy, mashed potatoes, buttered peas, bread and butter and strawberry chiffon pie

Wednesday: vegetable soup, toasted cheese bun, grapefruit and orange salad and chilled custard

Thursday: oven fried chicken, mashed potatoes, buttered beets, roll and butter and applesauce cake

Friday: pizza pie, coleslaw and apple crisp

Leptondale School:

Monday: frankfurter on roll, potato chips, buttered beans and fruit

Tuesday: hamburger and gravy, mashed potatoes, buttered corn, blueberry muffin and butter, applesauce

Wednesday: hot turkey sandwich, mixed vegetables, cranberry sauce and ice cream

Thursday: baked ham, mashed potatoes, buttered carrots, muffin and butter and jello with whipped cream

Friday: pizza on bun, coleslaw, pickle slices and applesauce cake

Wallkill School (Ostrander):

Monday: hamburger on a bun, ketchup, green beans, peach halves, milk

Tuesday: sloppy joe on a bun, lettuce salad, buttered carrots, tapioca pudding, milk

Wednesday: chicken chow mein on rice with Chinese noodles, carrot sticks, cinnamon square with butter, fruit, milk

Thursday: hero sandwich, tomato soup, Dutch apple cake, milk

Friday: macaroni and cheese, carrot salad, bread and butter, buttered spinach, cabbage and milk

School District Board of Education; a talk on building of the school by Robert J. Robinson, supervising principal of the district; a presentation of keys to the building by Mrs. Rolf Dryer, wife of the architect; a dedicatory prayer by the Rt. Rev. Msgr. Bernard A. Cullen, pastor of St. Benedict's Church in Wallkill and the Church of the Most Precious Blood in Walden; and a benediction by Monsignor Cullen. In a brochure given to each visitor, the school board pointed out, "Leptondale is one of the most attractive schools in the area. It was built for less than $16 per square foot, including the additional necessary heating, wiring and plumbing for a 10-room addition when needed."

Despite the new elementary buildings, burgeoning enrollment forced the district to continue using the Main Street Annex as a temporary elementary school for many more years, with a fourth classroom added in the 1960s. By 1964, high enrollment at the Wallkill Elementary School forced the need for additional elementary classes in the Wallkill Central School building.

The Wallkill Elementary School was renamed the Claire F. Ostrander Elementary School in 1965 in honor of former teacher and principal Clare F. Ostrander, who passed away that year. *Courtesy of Wallkill Central School District Historical Archives.*

The Wallkill Elementary School was renamed the Clare F. Ostrander Elementary School in 1965 in honor of former principal Clare Ostrander, who passed away in March of that year at the age of forty-six. Mr. Ostrander, a veteran of both Word War II and the Korean War, had served the district for nineteen years. He started his career in Wallkill in 1946 as a fifth-grade teacher, taught in the junior high school and became principal of the Wallkill Elementary School in 1956. Mr. Ostrander was also the assistant principal of elementary education for the Wallkill Central School District.

In the 1960s, the Wallkill Chamber of Commerce distributed a booklet describing the Wallkill Central School District:

There are five schools in our district. The junior-senior high school and elementary school are located in the village of Wallkill. In the nearby areas of Leptondale, Modena and Plattekill are three other elementary schools. Each of the three larger elementary school buildings within the district and the high school has its own professionally trained principal. Within the school district, but not uniformly at any grade level, Cuisenaire rods, words in color, SMSG math, team teaching, flexible scheduling, programmed textbooks, teaching machines, and broadcast ETV are being tried or strengthened. Often, such experimentation has been initiated by classroom teachers. There are libraries open all day long in each of the elementary schools, as well as in the junior-senior high school. Higher than average expenditures for books keep these libraries well equipped. The librarian of the Wallkill Public Library works closely with the school librarians to help promote a spirit of inquiry among the children. Specialized personnel assist the classroom teacher in giving attention to the needs of the whole child. Elementary classes are regularly scheduled with special teachers of art, music and physical education. School nurses, remedial reading specialists, speech therapist and psychologist are available to pupils needing special attention. Special consultants in mathematics and reading are regularly available. Special functions include band concerts, school plays, faculty plays, basketball, football, track, field trips and social affairs.

Not long after this booklet was published, the district began investigating the addition of a sixth school—a new high school that would house students in grades nine through twelve. In 1967, plans were made to reconfigure the Wallkill Central School District in preparation for the completion of the new

Robert J. Robinson was the district's supervising principal—a position similar to today's superintendent of schools—in the 1960s. *Courtesy of Wallkill Central School District Historical Archives.*

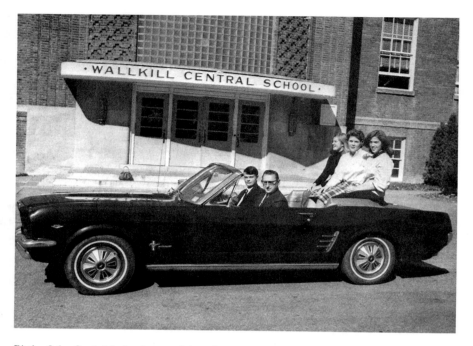

Birth of the Cool. Mr. Lenio, a social studies teacher, in his Mustang posing with 1967 Senior Class Officers Edward Terwilliger, Christine Kelly, Cathy Benedict and Jean Stillwaggon. *Courtesy of Wallkill Central School District Historical Archives.*

high school, which was under construction just off of Route 208 in Wallkill. Sixth-grade students were moved from the elementary schools to the middle school, where they joined the seventh and eighth grades. That same year saw the largest kindergarten class up to that point, with more than two hundred students (total enrollment at the new high school was approximately six hundred students).

The original access to the new high school was through Baumer Road, a town-maintained roadway. The district purchased a strip of land for the purpose of constructing a direct roadway to the school. In 1968, construction was completed on the Wallkill Senior High School, designed by the architectural firm of Clark and Warren. The new roadway to the school was christened Robinson Drive, in honor of Robert J. Robinson, who worked in the district for thirty-four years, first as a science and mathematics teacher and later as vice principal and supervising principal. Robinson oversaw construction of the new high school and retired as principal at the end of the 1968–69 school year. The Class of 1969 was the first to graduate from the new building. They posed for their memorable senior class picture

A 1969 cafeteria scene at the new high school on Robinson Drive. *Courtesy of Wallkill Central School District Historical Archives.*

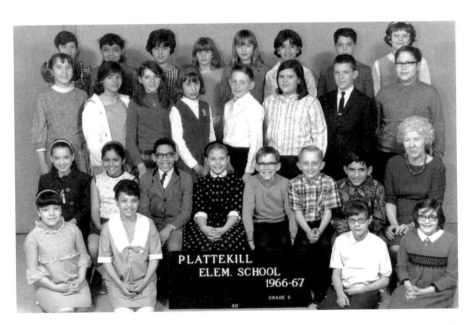

A Plattekill Elementary School fifth-grade class in 1966–67. *Courtesy of Wallkill Central School District Historical Archives.*

on some of the construction equipment that had been used to build their new school.

In the 1970s, proposals were made to build another school in order to meet the demands of a rapidly growing population. School district officials and Board of Education members investigated the possibility of building a second middle school near Route 32 and Patura Road in Modena that would house approximately six hundred students in grades five through eight.

In June 1973, former Modena School students toured the building that would close on June 30. The superintendent of schools at the time, Leonard Gunsch, is pictured standing, second from left. *Courtesy of Wallkill Central School District Historical Archives.*

The school would be built on property already owned by the district. The proposed modern building would have teaching areas with no interior walls but rather rooms divided by blackboards and shelving. Following several contentious votes—one defeated by only forty-nine votes and another by just twelve—the bond issue was defeated in April 1971. One major issue for taxpayers in creating a new middle school was concern over students not being able to access facilities that the existing middle school already had, such as the auditorium, gymnasium and cafeteria. The following year, voters approved a five-classroom addition at the Ostrander Elementary School, a small addition to the Leptondale Elementary School and a major addition to the Plattekill Elementary School.

On June 30, 1973, the last remaining neighborhood school, the Modena School, closed, and all students began attending the Plattekill Elementary School. The last teachers and staff in the building included teacher Judith Drake (kindergarten), teacher Katherine Van Vliet (fourth and fifth grades), teacher Ralph Flood (special education) and playground and bus aide Mrs. James Palen. The closure of the Modena School brought about the

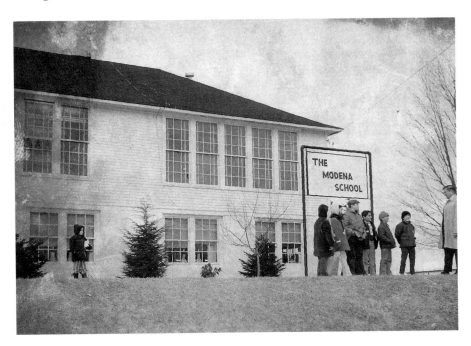

.The Modena School, one of the last of the neighborhood schools that once dotted the countryside. This picture was taken in 1974, just before the school closed. Today, the building houses the Plattekill Public Library. *Courtesy of Wallkill Central School District Historical Archives.*

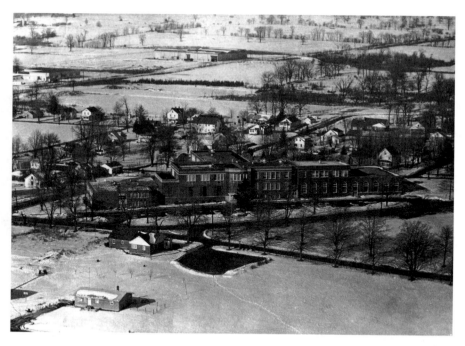

An aerial view of the former Wallkill High School. The buildings in the foreground no longer exist. *Courtesy of Historic Huguenot Street Archives, Kenneth E. Hasbrouck Collection, 1915–1994.*

end of nearly two centuries of common school education in the towns of Shawangunk, Plattekill and Newburgh and brought the district very close to the building configuration that still exists today.

In 1984, the Office of Educational Services was formed. In 1988, the office moved to the high school library before later being moved to the Main Street Annex building, which was by this time housing the district's administrative offices. By 1990, enrollment at the Plattekill Elementary School had outgrown the building, and so students in first and second grades once again had to attend school at Leptondale while a new eight-classroom addition was constructed. An extensive addition to the high school came in 1992 and included the auditorium, an extension to the existing library, increased guidance and administrative offices and several classrooms.

Bringing history full circle, the former high school on Route 208, later the Wallkill Middle School, was rechristened the John G. Borden Middle School in 2004. Members of the Historical Society of Shawangunk and Gardiner approached the district's Buildings and Grounds Committee with

Above: The Leptondale Elementary School on Mill Street in the town of Newburgh. The Leptondale Elementary School community celebrated the fiftieth anniversary of the building in 2009. *Courtesy of Historic Huguenot Street Archives, Kenneth E. Hasbrouck Collection, 1915–1994.*

Right: Ostrander students learn about fire safety during a special presentation in 2002. A New York City firefighter visited the students and spoke to them about the events of September 11, 2001. *Courtesy of Wallkill Central School District Historical Archives.*

Left: Elementary school students on the first day of school, circa 1980s. *Courtesy of Wallkill Central School District Historical Archives.*

Below: A Plattekill Elementary School class in 1984. *Authors' collection.*

the request that the Wallkill Middle School be renamed to honor the family that had played such a crucial role in the district's early history. Faculty and staff were asked to vote on the name change, and at its June 2004 meeting, the Wallkill Board of Education approved the renaming of the school, recognizing the integral role of the Borden family in the Wallkill Central School District. The renaming was officially presented to the community in August of that year by the members of the Shawangunk and Gardiner Historical Society. More than one hundred people attended the dedication ceremony, which included historical displays, slide presentations on Borden history and scrapbooks organized by Mary DuBois Wright, John G. Borden High School Class of 1937.

On June 23, 2012, veteran Patsy Paribelli of Plattekill became the oldest person honored at a Wallkill High School graduation. At the age of ninety-six, Paribelli received his high school diploma as part of Operation Recognition, a New York State program allowing eligible World War II veterans whose education was disrupted to finally receive their high school diplomas.

Wallkill Athletics: Hattowners, Blue Devils and Panther Pride

Hail! Ye members of Wallkill High!
Arise! And cast admiring eye
Upon our heroes; one and all—
Of our great team of basketball.
Salute ye proudly Bud, Norm, Wilson and Don,
Murphy, Jim, Walt, Moe, Arnold and John,
And still more to make your young hearts merry
There's Howie and Robert, Bob Striano and Jerry.
A vote of thanks to our managers, too,
To them our success is partially due.
So raise a cheer and sing our praise
Of this fine group that brightens our days.
—Anne Lynch, Wallkill Class of 1956

In 1928, Mr. Crane, the new principal, began to coach the team and also started basketball in the basement of the school. Only one game was played that year, against Pine Bush. The next year, $300 was donated by the townspeople to equip the Community Hall for basketball. Games were played there until a new gym was built in 1935. One of Wallkill's outstanding achievements on the basketball court was the victory over Highland this year, which was the first victory over Highland in the ten years we have played. It must also be mentioned that Wallkill's first championship was won by this year's girls' basketball team, coached by Mrs. Crane. This was the last year the girls are to be allowed in the NOSU

League, as girls interscholastic basketball is to be discontinued next year all over the state.—John G. Borden High School student Howard Terwilliger in his 1938 salutatorian address

The Wallkill Central School District has become known for its athletic traditions and its winning teams, which can be summed up in two words: Panther Pride! On any given day, parents, faculty, alumni and citizens pile onto bleachers in the gymnasiums and on the athletic fields to watch the Panthers do their work. In short, the teams that make up the Wallkill Central School District have always been a great source of pride. Even if students are not on teams, they are taught the central tenets of good sportsmanship, which has become synonymous with the title of Wallkill Panthers.

There is a long tradition of sports dating back long before the centralized district was formed. Prior to centralization, proposals were made to update the John G. Borden High School athletic facilities. This included building tennis courts for the students. There were two sites proposed for these courts—one on school grounds and another in the town park. Community members volunteered to help grade the property, while students proposed ways to raise money in order to lay out the court and hang the net. By the 1930s, the John G. Borden High School also featured strong boys' and girls' basketball teams.

An athletic field was purchased from the Wallkill American Legion in 1939. The following decade, the still newly created central school district was able to field junior varsity and varsity soccer teams for boys only, as well as a baseball team. Only basketball was available for both girls' and boys' teams. The seasons were not like they are today and would be considered very short by today's standards. Sometimes teams played fewer than ten games against neighboring schools, which included crosstown rival Walden High School. The football team played only six games in a season and was composed of six players. There were few seasons without trophies, as the tradition of winning started early for Wallkill.

In the 1930s, the first athletic trophy was won by the girls' basketball team, followed in 1944 by the boys' baseball team. There were no buses used to transport athletes to the games during that time. The Blue Devils, as the varsity basketball team was known, and the Colts, the junior varsity team, were brought to the games in the car of Principal Robert J. Robinson. Both teams were affectionately known as the "Hattowners," a reference to the hamlet's one-time hat factory. By the 1950s, the teams were also known as the "Blue and Whites," and by the early 1960s, all earlier monikers had given way to the Wallkill Panthers.

The decade of the 1940s was a big year for athletic programs in the Wallkill Central School District. There were special classes created in physical education for male students between the ages of seventeen and nineteen to prepare them for the military. The class met for five hours each week and included an obstacle course built by students on the athletic field. Instead of a physical education teacher, the students trained under the watchful eye of a military instructor. In addition to the physical training by the students, they were also taught how to march.

More teams were added in the late 1940s and early 1950s, including a cross-country team in 1948 and a spring track team by 1951. The former went on to win the Section 9 Class C races at Bear Mountain, beating Congers, Tappan Zee and Highland Falls. The team would practice on the roads and fields that were part of the Borden Farm. In 1949, a tradition of winning and excellence continued with the creation of a boys' volleyball team. This team went on to win fifteen consecutive league championships from the 1950s into the 1960s when competing in the Minor Sports Tournament of the Ulster County League. While no athletic teams existed for female students during this time period, a "Leaders' Club" was formed in 1949. Members would sell tickets at sporting events and help organize fundraisers. In addition, the club offered athletic opportunities for female students in the form of interscholastic games in a variety of sports. Girls would earn points for every activity

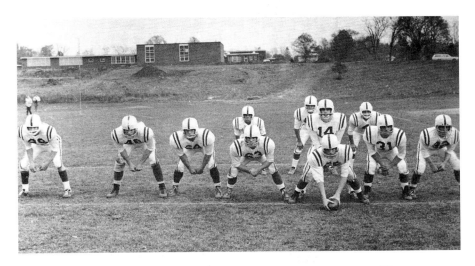

Go Panthers! An early picture of the football team with Clare F. Ostrander Elementary School in the background. *Courtesy of Wallkill Central School District Historical Archives.*

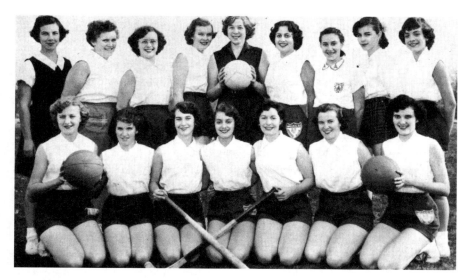

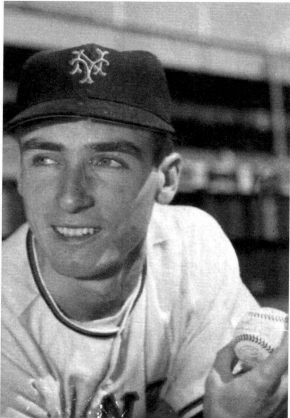

Above: Although there were no sports teams for female students in the district's early history, members of the Leaders' Club (shown here in the early 1950s) could earn a varsity letter for participating in a certain number of athletic events. *Courtesy of Wallkill Central School District Historical Archives.*

Left: Elmer "Al" Corwin, a graduate of Wallkill High School who went on to become a pitcher for the New York Giants. Corwin joined the Giants in 1951 and contributed to their National League Championship that year. Corwin was a major-league pitcher for five years, all of which he spent with the Giants. *Authors' collection.*

in which they participated. A certain number of points earned by their senior year would entitle them to a varsity letter "W."

Elmer "Junie" Corwin was the first noted Wallkill athlete to play for a professional team. He was drafted to pitch for the New York Giants. An issue of the *Wallkill Blue and White* proclaimed proudly in its October 25, 1951 issue that the New York Giants pitcher was in the World Series that year. The district supported students' interest in the local teams and during the 1953 World Series, between the New York Yankees and the Brooklyn Dodgers, students were able to go to the auditorium during their study halls and listen to the radio broadcast of the games over the PA system.

The new decade of the 1950s showed that Wallkill was the pride of Ulster County, with its Wallkill Blue and White Six Man Football team beating New Paltz 20–12 to win the Ulster County Interscholastic Six-Man Football Championship in October 1953. A celebration/dance was held in November to celebrate this victory. In the start of a long tradition in Wallkill, Jerry Headlam, who was the halfback on the team, and Elvira Garzon were crowned king and queen of the Wallkill Central School football team—a precursor to today's homecoming king and queen. The student council held food sales throughout the school year to raise the money necessary to purchase bleachers for the athletic fields. The elementary schools were not left out—under the direction of Central District Athletic Director Vincent

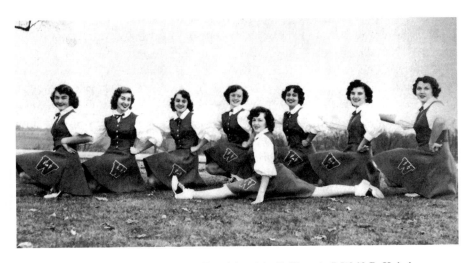

Wallkill Varsity Cheerleaders in 1954. *From left to right*: E. Kazmir, J. Wolf, B. Kobelt, A. Sheeley, A. Murphy, A. O'Conner and C. Backofen. Cheerleading began as an extracurricular activity at the John G. Borden High School and has evolved into a competitive sport. *Courtesy of Wallkill Central School District Historical Archives.*

DeAngelis and Girls' Athletic Director Kathleen Wisdom, annual field days were organized and held on the grounds of the Wallkill Central School to expose students to a variety of different sports and competitive games.

By 1950, the New York State Education Department had begun placing a greater emphasis on teaching physical education to students "to obtain educational outcomes." Educational objectives of physical education classes included "developing desirable standards of social behavior, personality, character traits, etc., developing desirable attitudes about wholesome living, and developing cultural appreciations." The incorporation of health education into physical education classes was required. It became mandatory for districts to report on not only how many boys and girls participated in intramural and interscholastic sports but also how they received instruction in first aid and guidance in activities such as hand washing and "working toward health goals." Intramural and interschool activities by this time included baseball, basketball, cross-country, six-man football, touch football, a rifle club, shuffleboard, table tennis, track and field and volleyball.

A monumental year in the history of Wallkill Central School District sports was 1958, when the girls' varsity and junior varsity basketball teams were started—a step that was way ahead of its time. They practiced on Tuesdays and Fridays. It is important to note that a junior high team would also be added in the 1964–65 school year. Girls' teams were expanded in the latter part of school year when a Girls' Sports Club was organized with the purpose of exposing female students to soccer, basketball, baseball and volleyball by playing games against other schools. According to the *Blue and White*, "The first and last soccer game of the season was played at Valley Central on October 26. The Varsity of Wallkill gained over their opponents a 6–2 victory. Although the Junior Varsity started out well, the Valley Central JVs inched up and won the game with a score of 4–2." A girls' swim team would be added in 1968 and would participate that year in a competition against Marlboro. The achievements of the girls' teams was only overshadowed by the boys' wrestling team, created by Coach Kenneth Brooker, which debuted in the 1964–65 school year. They participated in just one meet that first year and won a Mid-Hudson Athletic League (MHAL) championship title by the 1968–69 school year. Golf was also added for the first time in 1964, with players meeting at the "Missing Links" five-hole course near Kobalt Airport to practice.

After years of playing on the same athletic field, the Wallkill Central School District, with its still-new Wallkill Senior High School, decided to upgrade the athletic fields, and in 1972, the high school football team rewarded the community by winning its first game on the new field with a 12–6 victory over

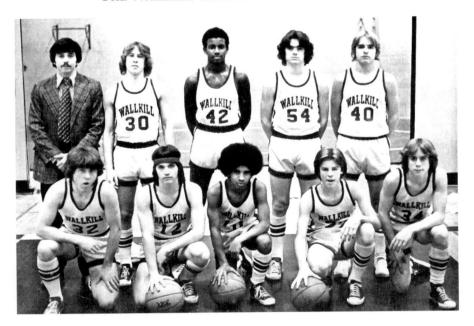

The Wallkill Boys Junior Varsity Basketball team in 1977. *Courtesy of Wallkill Central School District Historical Archives.*

Marlboro High School. Girls' field hockey, baseball, softball and soccer also made use of the growing complex of athletic fields.

The 1980s brought about the resurrection of the tennis team and the decision to dedicate the high school gymnasium to Vinnie DeAngelis, a longtime physical education teacher, health teacher, coach and athletic director. Three years later, the football team made the community proud by moving from the MHAL League to sectional play. One reason for the change was that there was no state championship in the MHAL League— another was the chance for new competition. Wallkill started as a Class B team in Section 9, along with neighboring New Paltz and Marlboro; today Wallkill competes in Section 9 Class A.

Today, the district participates in the Mid-Hudson Athletic League (MHAL), is a member of Section 9 and is considered a Class A school. High-quality programs have become the standard at Wallkill, the most recent accomplishments being the girls' varsity basketball team, under the guidance of Coach B.J. Masopust and Assistant Coach Sean Murphy, advancing to the Class A Regional Finals in Binghamton in March 2013 and the girls' varsity softball team, under Coach Chris Canosa and Assistant Coach Stephanie Adamshick, winning their first-ever Section 9 Class A Championship in June 2013.

Members of the physical education department of Wallkill High School in the 1960s: Gene Bilbao (rear), Vincent De Angelis, Mary Lou Williamson and Kenneth Brooker. The gymnasium at the Wallkill High School was named after De Angelis in 1986. *Courtesy of Wallkill Central School District Historical Archives.*

Construction of the new bleachers along the football field in the 1980s. *Courtesy of Wallkill Central School District Historical Archives.*

The following teams exist today at the John G. Borden Middle School and the Wallkill High School:

Boys' and Girls' Modified, Junior Varsity and Varsity Basketball
Girls' Modified, Junior Varsity and Varsity Volleyball
Boys' Junior Varsity and Varsity Lacrosse
Nordic Ski
Junior Varsity and Varsity Gymnastics
Modified, Junior Varsity and Varsity Softball
Boys' and Girls' Modified and Varsity Track
Indoor Track
Boys' and Girls' Modified, Junior Varsity and Varsity Soccer
Modified, Junior Varsity and Varsity Cheerleading
Modified, Junior Varsity and Varsity Wrestling
Modified, Junior Varsity and Varsity Baseball
Modified, Junior Varsity and Varsity Football
Boys' and Girls' Tennis
Boys' Golf

Members of the girls' softball team in 1990. *Courtesy of Wallkill Central School District Historical Archives.*

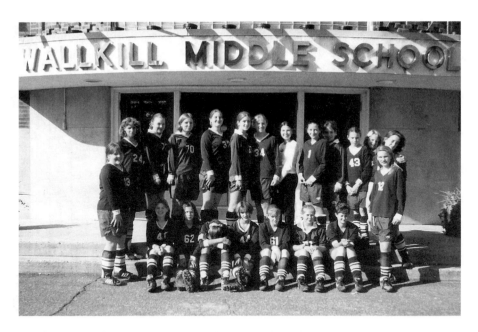

The former John G. Borden Wallkill High School later became the Wallkill Junior Senior High School and then the Wallkill Middle School. It was rechristened the John G. Borden Middle School in 2004. In this photograph, the modified girls' soccer team stands outside the building in the late 1990s. *Courtesy of Wallkill Central School District Historical Archives.*

Wallkill's Panther Pride and its accompanying winning spirit continued into the future, as did the important tradition of sports in the district. Realizing that excellence can be achieved only through practice, excellent equipment and facilities, the Wallkill Board of Education approved the request of students to christen a new soccer field on Robinson Drive in honor of Donald Andrews, who was superintendent of the district from 1984 to 2004 and a longtime supporter of Wallkill's athletic program.

The district also recognized the contribution every Wallkill athlete has left in the memories of the community by dedicating part of its athletic fields to the First Lieutenant Mark Dooley, a member of the Class of 1997 who was killed during the War in Iraq. In the fall of 2007, a portion of the district's cross-country course was named in Dooley's honor. Eric McLaud, the head coach of the Wallkill Cross-County and Track and Field teams at the time (later the district athletic director), read the following tribute to Dooley at the dedication:

> *The reason we are gathered here on this bright, sunny afternoon is to celebrate the life of First Lieutenant Mark H. Dooley, a member of the*

Class of 1997. Mark was also an integral part of the Wallkill Cross-Country and Track and Field programs for all of his high school career, serving as one of our captains both in his junior and senior years.

Mark was tragically taken from us one year ago while serving our country in this ongoing war on terrorism. He served our country the same way he served as our team captain—with honor, loyalty and pride.

We honor the principles that Mark stood for and demonstrated throughout his life by dedicating this area of our school as the Lieutenant Mark H. Dooley Corner. After much discussion about how best to honor Mark's life and to represent to future athletes what Mark represented, this corner will serve to forever remind athletes as they pass by here during the course of a cross-country race what Mark meant to all of us—not only as a student, athlete and soldier but also as a person who ran with a passion and served our country with that same passion.

Chapter 12

District Activities

This year, our school purchased an airplane to be studied by air-minded students. Approximately 30 boys got together and sent representatives to Mr. Robinson to ask if they might have an aviation club. Mr. Robinson agreed, but since there were so many boys, it was decided that they should build model airplanes upstairs and take turns working with the airplane. Several types and sizes of model planes have been constructed, including flying models. With the advent of spring, the boys went to work on the old PT 17, reassembling the wings and doing other minor jobs under the direction of Mr. Gardiner. The highlight of the year was taxiing the plane around the ball field.—Wallkill High School Aviation Club description, 1950s

Each September, when teachers are reviewing the school rules and going over the curriculum for the year and supplies needed by their new students, the question invariably comes up regarding what kind of afterschool activities are available at the school. Today, as long ago, there exists a comprehensive list as varied as the teachers that are employed in the district. Over the years, this has included everything from a high school Snowmobile Club to a Rifle Club to "WSBC"— a student-run television station. Parents have had the opportunity to actively participate in district activities ranging from the adult education programs held from the 1950s to the 1970s (which included the learning of simple maintenance on their cars to farm welding and even fireplace construction) to serving as volunteers for organizations such as the Panther Players High School Drama Club. When

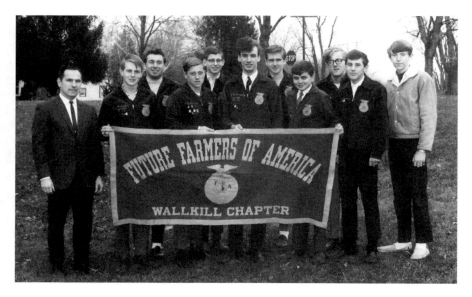

Members of the Wallkill High School Future Farmers of America, late 1960s. *Courtesy of Wallkill Central School District Historical Archives.*

one looks at the extracurricular activities offered by the district, he or she also gets a glimpse into how the community and its needs have changed over the years from primarily a farm community to a bedroom community for New York City. One such example is Future Farmers of America.

Future Farmers of America was organized in 1939. The following were officers: Paul Morna, president; Charles Smith, vice-president; Robert Lown, secretary; Vincent Bloomer, treasurer; and Robert Hughes, reporter. Its purpose was, according to a 1957 description, to create better members of farm organizations and to put the knowledge they learn as students in Future Farmers of America and in agriculture class to future use when they have their own farms. Students would sell seeds to raise money and participate in public speaking contests and county and state fair growing and animal competitions.

An integral part of student life at Wallkill has been and always will be extracurricular activities. Student involvement is seen as a testament of students' love for the school. One of the longest-running organizations has been the yearbook club, which dates back to 1924, when the John G. Borden High School's first yearbook was called the *Blue and White*. The yearbook was created by students with the assistance of staff members and edited by Verna A. Sheeley. It continued with the same title until

1940, when the name was changed to the *Kill-Kall*. (The new name was submitted by student Iris Caswell.) The 1940 yearbook also showcased some of the clubs and classes open to students at that time, which included "radio, dancing, glee club, and dramatics." The yearbook name again changed from *Kill-Kall* to the *Blue and White* in 1965. Another long-running tradition has been the school newspaper, which also continues today in the Wallkill Senior High School.

The district's first student high school newspaper was called the *Wallkill Blue and White*. It was created in 1940 with a faculty advisor by the name of Mrs. Herder. The paper would keep that name for some thirty-five years until it was renamed *The Paper Cut*. It is presently known as the *Wallkill Chronicle*. During certain times, school articles from the high school were also included in local newspapers such as the *Newburgh News*. In addition to the high school newspaper, several of the elementary schools and the middle school at various times created their own papers, such as the *Plattekill Monthly Star*, the *Modena School News*, the *Sylva Star* and the Leptondale *Black and Gold Bullet*. The junior high school came late to the game with the *Junior High-Light* in 1958. These two activities, whether the advisors and students involved realized it or not at the time, today form the heart of the Wallkill

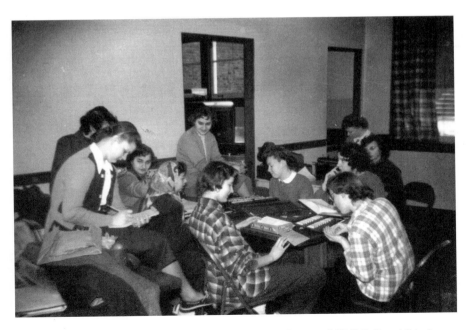

The Yearbook Club at the Wallkill High School, 1950s. *Courtesy of Wallkill Central School District Historical Archives.*

Central School District Historical Archives and played an integral part in the writing of this book.

One of the activities that over the years has defined the high school and the district is Homecoming. It demands total involvement by both staff and students and is looked forward to by the district. In fact, it is such an important aspect of the identity of the district that it was deemed a necessary part of the seventy-fifth anniversary. Memories into adulthood are formed at this monumental event. Modern-day Homecoming Court had its roots in the traditional crowning of a football king and queen, the purpose being "to create more team spirit among the boys and girls of W.C.S." Traditionally, the football queen was chosen as follows: two girls from each homeroom were nominated, and the nominated girls would then submit pictures of themselves. These photographs would be placed in a conspicuous place in the building. Students would judge each contestant according to her physical and personal attractiveness. Each student voted only once, and his or her vote would be placed in an envelope together with five cents. The winning contestant would receive a football autographed by all the members of the team. An integral part of Homecoming also involved another extracurricular activity—cheerleading.

Junior Prom King James Palen and Queen Janice Nicholson, 1968. *Courtesy of Wallkill Central School District Historical Archives.*

Members of the Wallkill High School Homecoming Court in 1999. *Courtesy of Wallkill Central School District Historical Archives.*

Varsity cheerleaders were chosen by members of the student council and faculty, while the junior varsity was chosen by the varsity. Girls would try out in the school gymnasium and were chosen based on, according to the October 3, 1951 *Blue and White*, "general appearance, technique and skill, uniformity in performance, originality, pep and poise." These were in turn kept on a scorecard, which was published in the November 8, 1951 issue of *Blue and White*. These same factors, in addition to "synchronization and uniform," were used as judging criteria for the annual Mid-Hudson Cheerleader Association meeting.

After thirteen years of education, the Wallkill experience ends in one regard but begins in another. It is a testament to the love both community and students have for their school district that so many teachers in the district today can trace their education to the Wallkill Central School District. They still have that Panther Pride and want to instill that pride in subsequent generations. There is no better time for reflection, gazing toward the future and pride in your school than commencement. Prior to the construction of the Marion Borden auditorium, commencement ceremonies were held in the Wallkill Reformed Church. During the 1940s and '50s, as part of the ceremony, students would cross a platform accompanied by flower girls

The Wallkill High School Future Nurses Club in 1963. Members of the club, along with the school's Parents Club, organized a clothing drive and collected more than 2,500 pounds of clothing. *Courtesy of Wallkill Central School District Historical Archives.*

or ushers. In 1951, the district started a new tradition of showing short films of each graduating senior. Seniors would also participate in a Class Day assembly in which their "prophecies" were read, along with the class history, and they would receive gifts from the junior class. Top students in the class were named, and their grade point averages (on a 4.0 scale) would be published in the local newspapers—but the district did not always choose valedictorians or salutatorians. Playing at commencement was the pride of Wallkill—its student orchestra.

Wallkill had a school orchestra as early as the 1920s. The orchestra included mandolins, pianos, violins, cornets, trombones and percussion. Students who participated in orchestra and maintained an overall average of 85 percent or higher were exempt from quarterly examinations. Students practiced in schools and at the homes of members, while also performing at various community functions. The district also had a Grade School Glee Club, a High School Glee Club and a Junior High Mixed Club. The first official band uniforms were described in the following manner:

> *The jackets are made of blue and white wool. On them is white braiding over the shoulders. A belt from the left shoulder comes down around the waist. The trousers are grey with blue and white stripes. The hats resemble army hats with the school emblem on the front.*

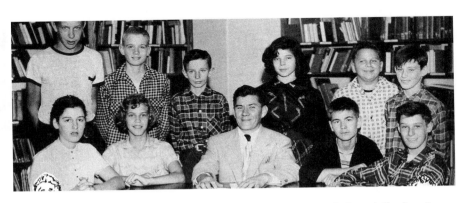

Well-known social studies teacher and local historian Kenneth E. Hasbrouck Sr., founder of Historic Huguenot Street in New Paltz, posing with his history club. *Courtesy of Wallkill Central School District Historical Archives.*

Opposite, bottom: Wallkill High School drum majorettes in 1967. *From left to right*: L. Imperato, G. Garrison, M. Rivera, C. Knoth, L. Napoleone and Head Majorette C. Pierce. *Courtesy of Wallkill Central School District Historical Archives.*

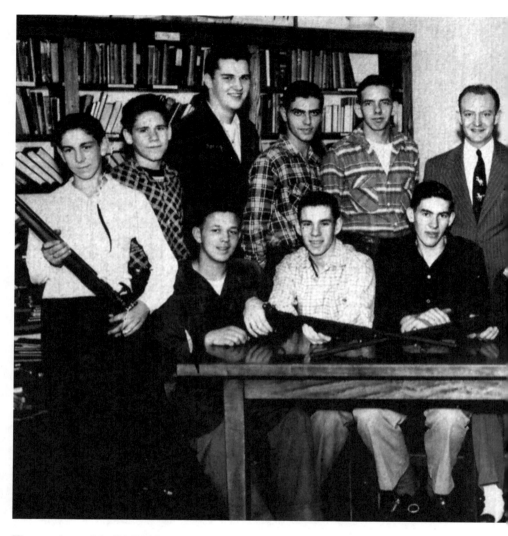

The members of the Wallkill Rifle Club pose for a picture in the Wallkill Central School Library in the 1950s. *Courtesy of Wallkill Central School District Historical Archives.*

There have also been what today would be viewed as more controversial clubs. There are numerous pictures in the district archives of students standing on the steps of the John G. Borden High School or in the school's library with guns in hand, showing off their .22-caliber rifles. Today, that would be cause for alarm; however, the Rifle Club was a popular activity in the lives of students for many years. The Rifle Club,

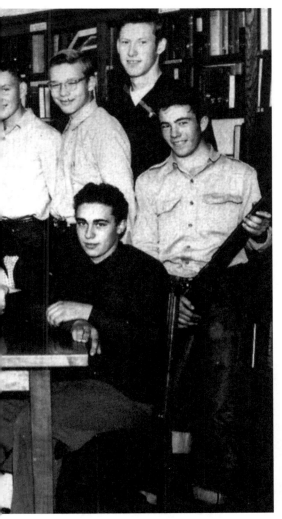

according to a 1957 description, remained small because practice space and equipment were limited. Both male and female students participated. The district owned four .22-caliber rifles, which students would use to practice target shooting at a range of fifty feet. Students had to be at least fourteen years of age and have some experience in handling a rifle in order to join. Dues were one dollar a year, part of which went toward National Rifle Association (NRA) dues. Club members purchased their own shells. The club's goal was to produce better marksmen. Toward the end of each year, the club held a rally in which students competed for the scores, which in turn qualified for the sharpshooter and expert marksmen badges that the National Rifle Association provided. They held regular meets in Ronk's Garage.

There were other clubs and activities that were more academic in nature, such as the Yorkers, in the 1950s and '60s, whose purpose was to promote the understanding and appreciation of the history of New York State and to develop projects that furthered interest in the community in which the members lived. Students worked with advisor Kenneth Hasbrouck to research the histories of the various hamlets and towns that made up the Wallkill District and published histories in the school newspaper and regional newspapers.

For those students that achieved academic excellence in their classes, the Shawangunk Chapter of the National Honor Society came into being in the 1950s. The National Honor Society at the Wallkill High School and

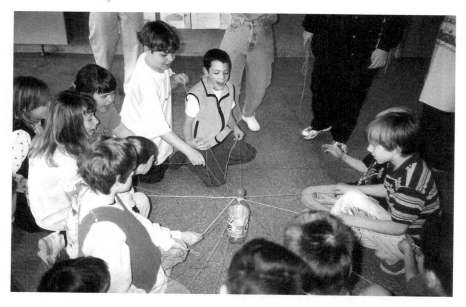

An elementary school team-building exercise during a physical education class, circa 2000. *Courtesy of Wallkill Central School District Historical Archives.*

John G. Borden Middle School students at the 2013 National Junior Honor Society Induction Ceremony. *Courtesy of Debra Rosenfeld.*

Elementary school students during a field-day activity in 2001. *Courtesy of Wallkill Central School District Historical Archives.*

Plattekill Elementary students in 1986 preparing to release balloons outside the school in memory of the astronauts who lost their lives in the explosion of the *Challenger* spaceship. *Courtesy of Wallkill Central School District Historical Archives.*

Ostrander students during a class activity in 2002. *Courtesy of Wallkill Central School District Historical Archives.*

the James Monahan National Junior Honor Society at the John G. Borden Middle School remain active today.

In the district's seventy-five years of existence, there have been too many clubs and activities to list them all. A sampling of the current clubs and activities at the five buildings include the following:

District-wide Spelling Bee
Family Math Nights
Sixth-Grade Olympics
Science Fairs
Authors' Day
Panther Players Drama Club
Student Government Association
Yearbook
Technology Club
Multi Flava (multicultural club)
Synthesis (Gay Straight Alliance)

Leo's Club (student branch of the Wallkill Lion's Club)
Talent Shows
Math Team
Student Forum
Band, Chorus and Strings programs
Art Shows
Relay for Life
Intramural Sports

Chapter 13

Wallkill at Seventy-five

The mission of the Wallkill Central School District, through an active partnership among school personnel, parents, students and community, is to nurture individuals who value themselves and others; to develop learners who appreciate diversity as a resource; to provide an exemplary educational foundation that will foster the ability to think and communicate; and to encourage creativity, flexibility, and the continuous application of learning—Wallkill Central School District Mission Statement

The learning community of the Wallkill Central School District seeks to continue the strong tradition of community involvement and a focus on high educational standards. It is because of these values, the district, over the last seventy-five years, has graduated responsible and productive citizens, many of whom continue to live in our community. The tradition will carry on!—Kevin Castle, Superintendent of the Wallkill Central School District

The 2013–14 school year marks the seventy-fifth year of the modern Wallkill Central School District. The centralized district consists of the Wallkill Senior High School, serving students in grades nine through twelve; the John G. Borden Middle School, serving students in grades seven and eight; and the Leptondale, Ostrander and Plattekill Elementary Schools. Approximately five hundred faculty, staff and administrators serve the students in these five buildings.

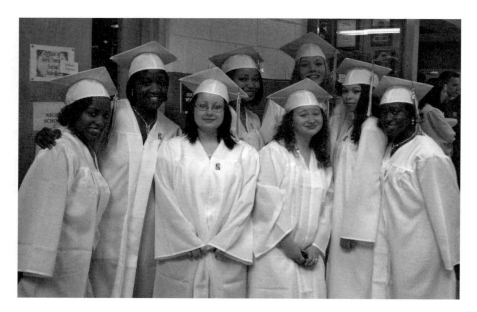

Graduates of the Class of 2006 pose for a picture. *Courtesy of Wallkill Central School District Historical Archives.*

The Wallkill Teachers' Association has instituted an annual tradition to honor graduates. Each year, teachers from all five buildings attend the Wallkill Central School District Commencement Ceremony and form two lines to welcome graduates as they step onto the football field for the start of the ceremony. Pictured here is a group of faculty and staff members from the 2006 commencement ceremony. *Courtesy of Wallkill Central School District Historical Archives.*

Each April, the Wallkill Senior High School recognizes the ten senior students with the highest cumulative average for their four years of high school. The students are commended by the Board of Education during its monthly meeting. The "Top Ten" for the Wallkill Senior High School graduating class of 2013 are Joshua Gehres (valedictorian), Marley Leary (salutatorian), Conrad Mossl, Steven DeVere, Salvador Santana, Lisa Losito, Hunter Krol, Ryan Walton, Kevin Presutti and Meghan Graham. They are pictured here with Wallkill High School principal Michael Rydell (left) and former superintendent of schools William Hecht (right). *Courtesy of Wallkill Central School District.*

The district administrative team includes: Superintendent Kevin Castle; Assistant Superintendent for Educational Services Yvonne Herrington; Director of Pupil Personnel Services Katherine Banks; Coordinator of Special Education and State/Federal Reporting Bridget Becker; Principals Michael Rydell (Wallkill Senior High School), Marjorie Anderson (John G. Borden Middle School), Richard Kelly (Leptondale Elementary School), Maureen Dart (Ostrander Elementary School) and Monica Hasbrouck (Plattekill Elementary School); and Assistant Principals Brian Devincenzi and Nicholas Pantaleone (Wallkill Senior High School).

The Wallkill Central School District Board of Education consists of nine members: Joseph LoCicero (president), Dennis O'Mara, (vice-president), Kathryn Anderson, Donna Crowley, Mitchell DeCoeur, Thomas Frisbie, Thomas McCullough, Vincent Petroccelli and Leif Spencer. Each year, a student representative is also assigned to serve with the board.

From the one-room schools that provided education for students in grades one through eight, the district is now proud to offer K–12 education to more than 3,500 students from the towns of Montgomery, Shawangunk, Plattekill,

The Wallkill Senior High School on Robinson Drive, constructed in 1968. *Courtesy of Wallkill Central School District Historical Archives.*

Gardiner and Newburgh—education that includes college coursework. Though the days of one-room schools are long past, the core values and emphasis on an education system that meets the needs of all learners once taught and practiced in those rural buildings remains a constant in the district today.

Bibliography

Anson, Shirley V. *Friends and Neighbors: A Pictorial History of the Town of Plattekill and Southwest Lloyd, Ulster County, NY*. Clintondale, NY: Clintondale Friends Meeting, 1989.

"Borden Family History." Interview with Rodney Thompson, April 15, 2013.

Boyce, Melissa. "History of the Modena School." *New Paltz Independent*, March 22, 1948.

"A Deed of Conveyance from William Thompson, Samuel Church and Silas Simkins to Peter Dougherty, 1812." Historic Huguenot Street Archives, New Paltz, NY.

EagleBrand.com. "Our History." http://www.eaglebrand.com/history/.

"Elaine Terwilliger Weed: Wallkill District History." Interview with Elaine Terwilliger Weed, April 17, 2013.

Finegan, Thomas E. *The Township System: A Documentary History of the Endeavor to Establish a Township School System in the State of New York from the Early Periods through the Repeal of the Township Law in 1918*. Albany: University of the State of New York, 1921.

George, Leonard. "History of the Benton Corners School." *New Paltz Independent*, May 6, 1948.

Gunsch, Leonard P. "Development and Evacuation of a Resource Handbook for the Leptondale Elementary School." Thesis, Cornell University, 1962.

"Handbook for Teachers, Central School District No. 1, Wallkill, NY (1950–1951)." Leonard George papers. Historic Huguenot Street Archives, New Paltz, NY.

Hasbrouck, Kenneth. *History of Forest Road*. Self-published, 1949.

————. *History of Leptondale.* Self-published, 1948.

————. *History of New Hurley, The Flint, Plains Road, Sherwood Corners, St. Elmo.* Self-published, 1949.

————. History of the Township of Gardiner: 1853–1953 Centennial. Gardiner, NY: Town Board of Gardiner, 1953.

————. *History of the Township of Shawangunk.* Newburgh, NY: D.A. Stillwaggon, 1955.

Hasbrouck Zimm, Louise, A. Elwood Corning, Reverend Joseph W. Emsley, and Willitt C. Jewell, eds. *Southeastern New York: A History of the Counties of Ulster, Dutchess, Orange, Rockland and Putnam.* New York: Lewis Historical Publishing Company, 1946.

Headley, Russell. *The History of Orange County, New York.* Goshen, NY: Orange County Genealogical Society, 1993.

"Historic Sketch and Inventory of Historic Places in the Shawangunk Valley, Ulster County, New York." The Shawangunk Valley Conservancy, February 1980.

"History of Wallkill Central School District—Part 3." March 11, 1948. Leonard George papers. Historic Huguenot Street Archives, New Paltz, NY.

Kingston Daily Freeman. "County Residents at Wallkill Pass Centralized Plan." November 1, 1938.

————. "Funeral Services Held for Miss Marion Borden before 400 in Wallkill Reformed Church." November 4, 1930.

————. "Ulster Girl Scout Council Pays Tribute to Memory of Marion Borden." November 19, 1930.

————. "Misc. Notes." May 23, 1935.

————. "Wallkill's High School Dedicated." September 6, 1922.

————. "Wendy Scouts in Memorial to Their Benefactor." August 7, 1935.

Klukkert, Vicky. "Wallkill Honors Its Most Famous Dairy Man." *Wallkill Valley Times,* August 25, 2004.

Kniffen, Elaine. "History of the Plattekill School." *New Paltz Independent,* March 25, 1947.

Mabee, Carlton. *Gardiner and Lake Minnewaska.* Charleston, SC: Arcadia Publishing, 2003.

"Mary Anne Brown Papers (1812–1901)." Historic Huguenot Street Archives, New Paltz, NY.

McAleese, Jessica. "At 96, Patsy Paribelli Is Finally Getting His High School Diploma." *Wallkill Valley Times,* June 20, 2012.

Mentz, Frank. *Shawangunk Hearths: Recollections of an Old-Timer, as Told to Vera Seely.* Wallkill, NY: Wallkill Public Library, 1974.

Middletown Record. "Public School Inspection of Wallkill School Slated Next Week." April 27, 1946.

Morse, Audrey. "Taught 40 Years, Never Missed a Day for Illness." *Newburgh Evening News*, June 14, 1973.

Newburgh Daily Journal. "Sylva Items." February 10, 1893.

Newburgh Evening News. "Auction Planned at Old School." October 5, 1965.

————. "Austerity Budget Planned for Wallkill." May 8, 1971.

————. "News of Granges." September 30, 1930.

————. "Plattekill School Reunion on Saturday." September 5, 1929.

————. "School Board Airs Petitions." March 18, 1946.

————. "School Is Over-Crowded." August 12, 1931.

————. "Schools to Aid Temperance Rally in Plattekill Area." May 24, 1935.

————. "Union at Plattekill Will Give Program on Community Night." May 3, 1930.

Newburgh News. "500 at Leptondale Dedication." November 12, 1959.

————. "Sylva School Closed with Athletic Tests and Picnic Awards." July 2, 1931.

————. "Large Throngs Attend Open House at Wallkill School." May 2, 1946.

————. "Town May Buy Modena School." February 20, 1982.

————. "Visits to the Schools." (Supervisor Reports). May 22, 1873.

————. "Visits to the Schools." (Supervisor Reports). December, 1874.

————. "Wallkill Central District Schools List Faculty Members." September 18, 1954.

————. "Wallkill School Plan Opposed in Plattekill." December 8, 1951.

New Paltz Independent. "Visits to the Schools." (Supervisor Reports). January 30, 1873.

New York State Education Department. "History of the Board of Regents." http://www.regents.nysed.gov/about/history.html.

New York State Legislature. *Documents of the Assembly of the State of New York: One Hundred and Forty-First Session, 1918*. Vol. 24, Part I, No. 45. Albany, NY: J.B. Lyon Company, printers, 1918.

New York Times. "Players and Singers of 14 Schools Appear in Music Festival at Teachers College." May 13, 1934.

Novinson, Michael. "World War II Vet Finally Gets Diploma." *Times Herald-Record*, June 24, 2012.

Orlowski, Albina. "First Day of School in Plattekill 85 Years Ago." *Newburgh Evening News*, May 8, 1971.

————. "History of Old Plattekill School is Recalled as Alumni Plan a Reunion." *Newburgh Evening News*, October 27, 1955.

————. "Passing of Modena Elementary School." *Walden Citizen*, June 6, 1973.

Rhoads, William B. *Ulster County, New York: The Architectural History and Guide*. Delmar, NY: Black Dome Press, 2011.

Rice, Cheryl A. "Celebrating a Legacy of Philanthropy." *Wallkill Valley Times*, August 26, 2009.

Schenkman, A.J. "Ulster County Philanthropist: Marion Borden." http:// newyorkhistoryblog.org/2013/05/08/ulster-county-philanthropist-marion-borden/.

Smiley, Alfred. "A Unique Borden Family Legacy—The Borden House." http://hvanaken.com/wallkill/Houses/BordenHouse/BordenHouse.html.

Sylvester, Nathaniel Bartlett. *History of Ulster County, New York: With Illustrations and Biographical Sketches of Its Prominent Men and Pioneers.* Woodstock, NY: Overlook Press, 1977.

Terwilliger Weed, Elaine. *One-Room Schools of the Town of Shawangunk, 1800–1943.* Washingtonville, NY: Spear Printing Company, Inc., 2010.

Times Herald-Record. "Legal Notice: Savilton School." July 3, 1974.

Ulster County Clerk's Office. "Ulster County Clerk, Archives Division." Accessed May 11, 2013.

Walden Citizen Herald. "New Name for Central School at Wallkill." November 29, 1945.

———. "New School Voted at Wallkill." December 26, 1940.

———. "Young America Celebrates: High School Crowd March to Wallkill and Serenade Fellow Students; May Regret Later." November 1945.

Werlau, Elizabeth. "Police Headquarters Began as Trendsetting School." *Southern Ulster Times,* July 20, 2011.

Williams-Myers, A.J. *Long Hammering: Essays on the Forging of an African American Presence in the Hudson River Valley to the Early Twentieth Century.* Trenton, NJ: Africa World Press, 1994.

WALLKILL CENTRAL SCHOOL DISTRICT HISTORIC ARCHIVES

The Blue and White, 1941–1970.

Bruynswick School registers.

Clerk's Book, Volume First, Plains Road District No. 2 of Shawangunk, Ulster County and District No. 9 of Newburgh, Orange County, October 28, 1842, to August 4, 1908.

Minute Book of the Board of Education of Central School District, Wallkill, NY. September 12, 1919, to July 18, 1929.

Minute Book of the Board of Education of Central School District, Wallkill, NY. August 14, 1929, to July 27, 1936.

Proceedings of the Board of Education of School District No. 5, Union Free High School. March 15, 1908, to August 31, 1915.

Savilton School registers.

Index

INDEX

About the Authors

A.J. SCHENKMAN is a social studies teacher in Ulster County and a freelance writer. He is the author of the popular *Wicked Ulster County: Tales of Desperadoes, Gangs and More* (The History Press), as well as two earlier publications: *Washington's Headquarters in Newburgh* (Arcadia Publishing) and *Washington's Headquarters: Home to a Revolution* (The History Press). He has published numerous articles on Hudson Valley history in publications such as *Ulster Magazine*, the *Times Herald-Record*, *Chronogram* and on his website, Ulster County History Journal (www.ucnyistory.com).

ELIZABETH WERLAU is an English teacher in New York State's Hudson Valley region. She is the author of *Images of America: Plattekill and Hallowed Grounds: Historic Cemeteries of the Town of Plattekill, NY* (coauthored with Shirley Anson). In addition, she has published numerous articles on the Hudson Valley for the Times Community Newspapers of the Hudson Valley, the *Hudson Valley Business Journal* and on her website, Ulster County History Journal (www.ucnyhistory.com). Ms. Werlau currently serves as president of the Plattekill Historical Society, as a member of the board of directors of the Ulster County Historical Society and as a researcher/writer for the Wallkill Valley Land Trust's annual Houses on the Land tours.